PORTRAITS
DUNCAN EVANS

 Essentials

Published by AVA Publishing SA
Rue des Fontenailles 16
Case Postale
1000 Lausanne 6
Switzerland
Tel: +41 786 005 109
Email: enquiries@avabooks.ch

Distributed by Thames & Hudson (ex-North America)
181a High Holborn
London WC1V 7QX
United Kingdom
Tel: +44 20 7845 5000
Fax: +44 20 7845 5055
Email: sales@thameshudson.co.uk
www.thamesandhudson.com

Distributed by Sterling Publishing Co., Inc.
in the USA
387 Park Avenue South
New York, NY 10016-8810
Tel: +1 212 532 7160
Fax: +1 212 213 2495
www.sterlingpub.com

in Canada
Sterling Publishing
c/o Canadian Manda Group
One Atlantic Avenue, Suite 105
Toronto, Ontario M6K 3E7

English Language Support Office
AVA Publishing (UK) Ltd.
Tel: +44 1903 204 455
Email: enquiries@avabooks.ch

ISBN 2-88479-104-3 and 978-2-88479-104-5

10 9 8 7 6 5 4 3 2 1

Production by AVA Book Production Pte. Ltd., Singapore
Tel: +65 6334 8173
Fax: +65 6259 9830
Email: production@avabooks.com.sg

HOW TO GET THE MOST FROM THIS BOOK

This book introduces different aspects of photographic portraits via dedicated sections for each topic. The text offers a straightforward guide to the most frequently asked questions alongside photographic examples and technical diagrams.

Sections
This book is divided into eight sections, each one exploring a different aspect of portraits. The sections are identified by a different colour. The opening pages of each section clearly display the colour for that chapter.

Topics
The topics in each dedicated section are all listed on the subject introduction page.

Colour-coded tabs
Colour-coded tabs appear in the corner of each page to identify the section.

Clear navigation
Each of the 50 topics is numbered in the top corner of the page to make them easy to find.

Visual explanations
Each question is illustrated using a series of photographic examples.

Diagrams
Additional technical information is provided and explained by the use of simple diagrams and icons.

Tip
The Shadow/Highlight tool is useful in extending the effective range of fill-in flash. Fill-in flash can't provide sufficient light to illuminate a dark or distant background without washing out the foreground subjects.

Tips
Look out for these panels, which offer handy tips on a variety of topics.

FAQs
A complete list of all the FAQs appears alongside the subject index.

See also
Subject brightness range (page 85)
Understanding stops (page 72)

See also
See also boxes cross-reference a topic to other related questions or topics that appear in the book.

Icon key

A simple reference guide to the symbols used within the diagrams.

Camera

Light source

Fill light

Light meter

Subject

 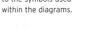

PHOTOGRAPHY FAQs
PORTRAITS

PORTRAITS
FREQUENTLY ASKED QUESTIONS

ESSENTIAL HARDWARE

METERING

USING COLOUR AND MONOCHROME

PORTRAITS
FREQUENTLY ASKED QUESTIONS

NATURAL LIGHTING AND SUPPLEMENTARY FLASH

STUDIO LIGHTING

COMPOSITION AND POSING

FREQUENTLY ASKED QUESTIONS

SHOOTING ON LOCATION

THE DIGITAL DARKROOM

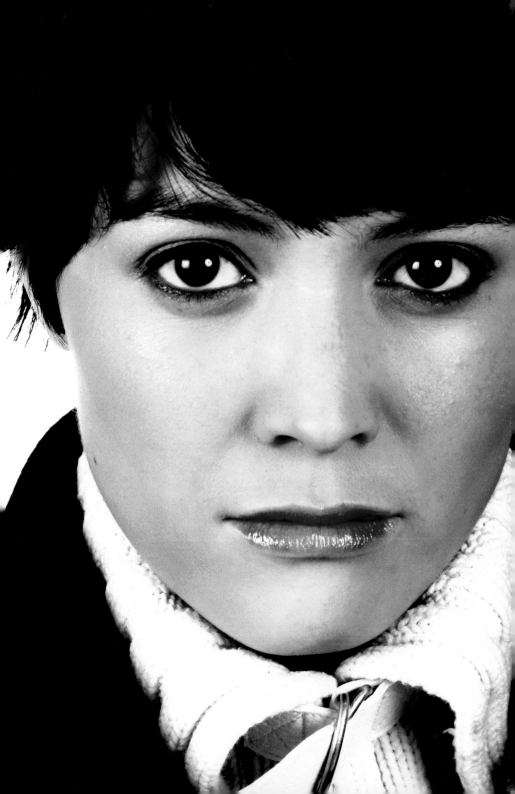

INTRODUCTION

Welcome to Photography FAQS: Portraits, where hopefully you'll find answers to all the questions you've ever wanted to ask about shooting portraits. The portrait is one of the most popular photographic subjects – wherever and whenever there's a camera, someone will be using it to photograph people. However, simply leaving the camera to automatic settings and just snapping away produces mediocre pictures every single time. Better results are attained only when you take control of the camera functions, arrange the lighting, compose the subject, and dictate what type of portrait you want.

While the digital user will produce images that have the characteristics common to a specific manufacturer and camera range, the film-SLR user has a choice of emulsions to pick from, which determine the look and feel of a portrait. We will look at these before assessing the types of lenses available, and what effects they have on the image.

Lighting is the other key element in portrait photography, so questions regarding flashguns, built-in flash, artificial lighting, diffusion, reflectors and studio accessories are also addressed.

Of course, getting the picture exposed correctly is a crucial element and this is where the section on metering comes in handy. Here, we look at the differences between ambient and direct lighting, and the metering options of reflected and incident light. Metering is fully explained and a guide to useful modes for portraiture is provided. Exposure techniques are also looked at to ensure you get the image you want.

There is a section on colour and monochrome, both from the perspective of colour temperature and what effect this has on the mood of portraits. We will also discuss how to cancel colour casts using digital and film, and the language of colour and what it says in a portrait.

The properties and implications of light are also discussed. Sunny days may seem perfect for getting out and photographing portraits, but it's actually far easier to shoot and capture excellent images during overcast days.

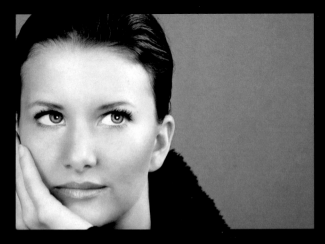

Your subject doesn't need to be looking at the camera to make an effective portrait.

While the elements are wild and unruly, the world of studio photography is a carefully planned exercise with an almost military precision. Almost. While most amateurs cannot afford their own fully fitted studio, there is plenty of affordable electronic flash lighting gear available with a range of accessories that can turn any spare room into a temporary studio.

Once you have the technicalities under control, the next main issues for anyone taking portraits are composition and posing: how and where to place people, how much to include, what to do with feet and hands, what problems to avoid and whether or not to have your subject make eye contact. Once lighting and exposure are mastered, composition and posing are what separate great images from mediocre ones.

The final parts of this book deal with the problems, pitfalls and solutions of shooting on location, and what you can do with digital images once they are on the computer. These photo-editing techniques for portraits are just as applicable for film users as they are for those shooting in digital. We live in a digital world, so it makes plenty of sense to scan prints and slides and make use of the digital darkroom tools on offer.

To the uninitiated, the world of portraiture may seem quite simple. However, like an iceberg, once you start to investigate beneath the surface, there is far more to shooting portraits than pointing a camera at someone grinning and then firing away. I hope you'll find this book useful, informative, inspiring, and in time, a well-thumbed resource with all the answers to your questions on portraiture.

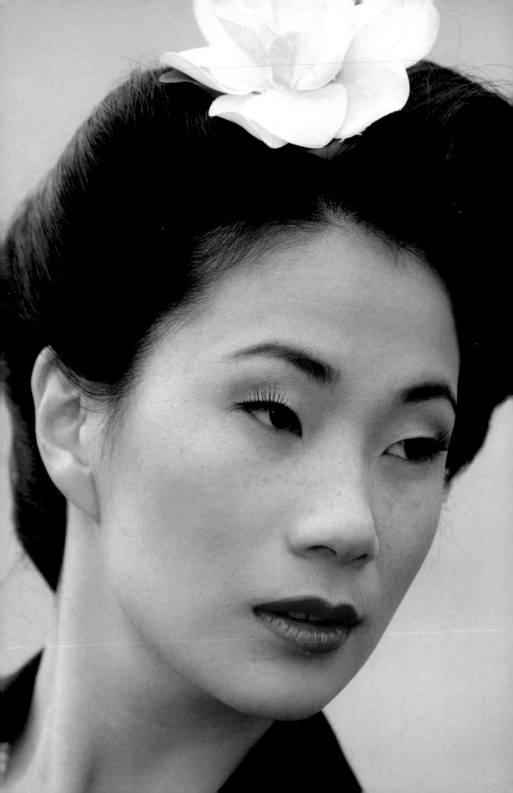

SECTION ONE

ESSENTIAL HARDWARE

It goes without saying that unless you have a camera, you won't be taking any pictures, but what kind of camera and accessories do you actually need for portraits? While 35mm film has largely given way to digital in all but specialist areas and amongst hardcore supporters, it does still have some advantages, particularly in the wedding market. Plus, medium format is still alive and kicking. This opening chapter has a look at what film stocks can do as well as what resolution and type of digital camera is best for shooting portraits. Once the format is decided, you need lenses and the choices here are critical to how your portraits appear. There are also crucial accessories such as flash and studio lighting gear to consider. What do you need? What would be useful for the portrait photographer?

A lens with a wide aperture will enable you to get the background out of focus, removing distracting elements.

What kind of digital camera do I need for portraits?

While it is possible to take a portrait with any kind of digital camera, there are reasons why certain types of cameras are better than others. Essentially, the choice is between a digital compact camera with a built-in lens and a digital SLR that features interchangeable lenses. While the image resolution of both types can be similar, it's their characteristics that set them apart.

The main reason for buying a digital SLR (DSLR) rather than a compact, if you are engaged in portrait photography, is depth of field. This is dealt with in more detail later, but briefly, it is the depth of the picture that is rendered in sharp focus. Portraits benefit from shallow depth of field so that the background becomes diffused and does not detract from the subject.

A DSLR gives the portrait enthusiast far more control over how the image looks than a compact camera.

Due to the use of a smaller charge-coupled device (CCD) and the arrangement with the lens, compact digital cameras produce up to five times more depth of field at the same aperture as an SLR – this makes it much harder to get the background out of focus.

What is shutter lag?

This is the delay between pressing the fire button and the image being captured by the camera. It's the delay between the fire button being half-pressed, where the camera meters and focuses, and then being fully depressed to take the shot. Compact digital cameras suffer from shutter lag more than SLRs. Typically, you are talking about 0.15 seconds to 0.25 seconds for a compact, but 0.04 seconds to 0.08 seconds for a consumer level DSLR. These time increments sound insignificant, but if the subject is moving, they can be out of frame when the shutter is actually released. Most portraits feature people sitting still, but if you are shooting at a party, a big group or a sporting event, it can have an effect.

See also

Depth of field in portraits (page 92)

If the subject is standing or sitting still, shutter lag isn't much of an issue. However, if they are moving, or if you are trying to capture candid pictures, they could be off the screen when the camera actually captures the image.

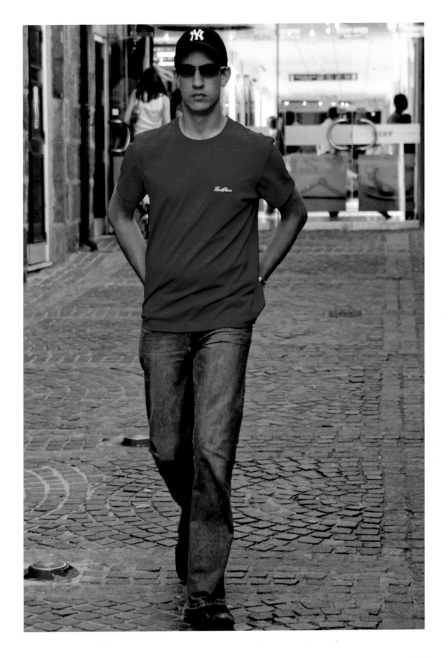

What kind of resolution is required?

Digital image resolution is the number of picture elements, or pixels, captured by the CCD or complementary metal-oxide semiconductor (CMOS) at the heart of a digital camera. Each pixel represents one small coloured dot in the final image. The horizontal and vertical resolutions are multiplied to achieve the total image resolution, which is expressed in terms of millions of pixels – or megapixels. So how much is enough? Do you really need a camera that boasts 12Mp? If you are shooting single subjects or couples and the final output is to be no more than A4 size then a 6Mp camera is fine. If you are shooting groups more detail is generally required, so 8Mp or 10Mp would be better. If the printing output is going up to A3 in size, then 10Mp, 12Mp or higher is desirable.

What does portrait mode do?

You will see the little face icon on almost all compacts and plenty of entry- to mid-level DSLRs. This represents the portrait mode. Selecting this will tell the camera that you are shooting a portrait and it will try to optimise the picture accordingly. At the least, it will attempt to create a shallow depth of field, but in the world of compacts these days, it will usually also process the image to give fairer and softer skin tones.

Most digital compact cameras and many entry- to mid-level DSLRs have a portrait mode, signified here by the person icon on the command dial.

If all else fails, try to capture the personality of the subject. An engaging expression can turn an average image into something worth saving.

What is shooting speed?

This is the number of shots per second, or frames per second (fps) that the camera can capture. For standard portraits it's not very critical, but for fashion portraits it is quite handy to be able to kick out 3fps to get some energy and movement into the pictures. If the subject is engaged in an active sport or pursuit rather than just sitting in front of the camera, then fast shooting will help capture the action.

What is burst mode?

This is similar to shooting speed and is more a feature of compact digital cameras. It's the fps that can be achieved for a limited time, usually until an internal memory buffer fills up, after which the camera slows down to the usual rate of fire. The burst mode is usually short-lived and averages around 2fps, although there is the odd compact that can hit 3fps and sustain it.

The sensor unit of the Nikon D300 is the heart of the image-capturing process.

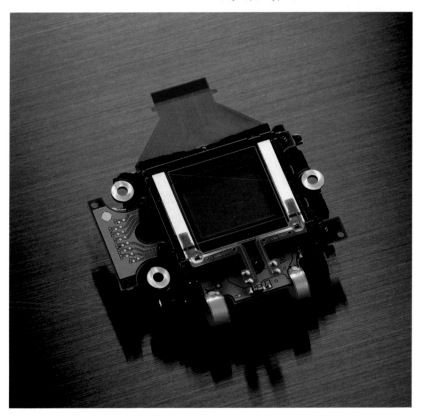

Which is best for portraits, slide or print film?

Positive slide film has the advantage of there being only one process involved in bringing forth the image. Negative print film involves producing the negatives and then printing images from them; the process uses two stages and therefore produces a lower quality result. Slide film also has the capacity for greater colour saturation.

However, negative print film has greater tonal range than slide film. This allows for the effective capture of detail between complete black and pure white. Slide film has around four or five f-stops of tonal range, whereas print film has seven or eight. Differences are not noticeable on a grey day. However, in scenes of high contrast (for example, when the sun is shining or when shooting weddings where there is the extreme contrast between grooms in black and brides in white), the advantage of print film pays off.

Fujifilm's Neopan 400 Professional black-and-white film with ISO 400 gives a fast response with smooth grain.

Which is better for portraiture, slow film or fast film?

The speed of the film refers to its ISO rating and how quickly it can respond to light. Slow film features fine grain - it is slower, requires more light and thus needs wider apertures or slower shutter speeds than faster film. However, the very presence of fine grain can mean that every flaw in complexion is picked up, whereas a faster film featuring larger grain tends to give a more even complexion. Note that we are not referring to the high grain and contrast black-and-white films here.

What would you use for shooting weddings?

Professional print film has a distinct advantage when shooting weddings. Fujifilm is one of the biggest manufacturers and supporters of film and has a wide range of stocks that include ones specifically produced for portraits. The results display superb skin tones and have a neutral grey balance with fine grain. The Fujicolor Pro 160S is one such dedicated portrait film stock, which is available in 35mm or 120 roll film formats. A version called Fujicolor Pro 160C is also available - it is not calibrated for skin tones as such, but for high-contrast situations. For higher speeds and shooting weddings, the Fujicolor Pro 400H produces great skin tones and smooth grain, and is fast enough to cope with low and challenging light. For extremely low light (receptions or gloomy castle locations), the Fujicolor Pro 800Z offers an ISO of 800 and produces images with natural skin tones. This truly is one of the few advantages that film has over digital - you can get a film stock that will create superb results in specific conditions.

This image was shot using the classic Ilford HP5 at ISO 400. This monochrome portrait has superb tonal range.

How do I get that grainy black-and-white look?

Films such as the Kodak Professional T-Max P3200 film feature a high ISO rating of 3200, which produces very sharp black-and-white images. While the grain is finer than many films of lower ISO ratings, it also has the advantage that it can be 'pushed'. This means that it can be processed in the lab at a higher ISO rating, which makes the grain more prominent. Other stocks such as Kodak's Professional Tri-X 400TX are renowned for their distinctive and dramatic grain structure.

Are films geared towards specific subjects?

There are numerous stocks available for various occasions: weddings, general portraits, sharp slide film for portraits where enlargement is necessary, and a host of black-and-white films. These range from ultra high-quality and fine-grain shots featuring superb tones, to grainy, high-speed stocks for music venues and dark, atmospheric conditions.

What is focal length?

This is the distance from the centre of a simple lens, suspended in air, to its point of natural focus. Lenses in cameras consist of numerous glass elements that help to straighten and sharpen the resulting image. The term 'focal length' still applies and is used to indicate how close the lens makes the image appear, and how wide the field of view is. The size and position of the recording medium also play a part in determining the focal length when discussing 35mm film cameras. This changes when it comes to digital cameras, and these changes will be explained later.

What is aperture?

The aperture is expressed as an f number. It is the ratio between the focal length and the physical size of the opening (or aperture stop) in the lens. Aperture determines how much light passes through the lens. As the aperture is linked to the amount of depth of field in a photograph, having a wide aperture (or low f-stop, such as f/1.4 or f1.8) produces very little depth of field. This means that the background will be out of focus and will not detract from the subject. Wide apertures and shallow depth of field are very useful in portraiture.

What is a portrait lens?

A portrait lens produces an image that is similar in distance to the photographer's original view at the time of image capture. This is generally considered to be around a 50mm focal length, as fitted to a camera with a 35mm film frame. However, even using a 50mm lens at close range can lead to distortion, so lenses with a longer focal length can also be labelled as portrait lenses. The other factor that helps to identify a lens as being suitable for portraits is the one with the widest aperture possible, such as f/1.4 or f/1.8.

What is a prime lens?

A prime lens is one that has a fixed focal length. This means it has a fixed field of view and a fixed subject-to-camera resolving ratio. If you want the subject to appear larger when using a prime lens, you have to move closer to the subject. Prime lenses tend to produce sharper images, suffer less distortion and offer better contrast than zoom lenses. A prime lens can usually offer a wider aperture as well.

Left: Every portrait photographer should consider the 50mm prime lens a must-have for their kit bag.

Right: If you want to use zoom lenses, restrict the range to get better aperture performance.

What is a zoom lens?

A zoom lens can change focal length, bringing things closer or widening the view. The bigger the range the zoom covers, the lower the overall quality and the more limited the performance. In portraiture, the zoom lens has the advantage of being very flexible; as a short telephoto lens, it offers a good balance.

What is focal length extension?

As mentioned previously, the lens is usually placed at the same distance from the recording plane as the focal length itself. As the recording chip of a digital camera is smaller than a 35mm film (while using the same lens system and positioning), it only records the central area of the image, discarding the outer areas. This image is then presented at full size and shows a narrower field of view and a shorter distance to subject – as if a longer focal length had been used. This is the effective focal length extension of a digital camera. On most, it is approximately 1.5x. For portraiture, this means our 50mm lens becomes a 75mm lens. The focal length shift allows subjects farther away to be brought closer. However, it is more difficult to obtain wide-angle views. This results in wider angle lenses having to be used in order to get the same field of view possible on a 35mm film camera, which also introduces more distortion.

The above two pictures show the effect a 1.5x focal length extension has on a picture with regards to the lens – it brings the subject closer. Note that the digital user will simply see the second picture through the viewfinder.

What is a wide-angle lens?

Generally, a lens with a focal length of less than 50mm is considered a wide-angle lens; however, the definition applies mainly to 35mm lenses and less. These lenses show a wider area, which is useful for getting more people in the shot. However, bear in mind the focal length extension factor of a digital camera. A 28mm wide-angle lens becomes 42mm – not a very wide lens on a DSLR.

Wide-angle lenses are useful for shooting in small areas, but will distort images. They lengthen what is closest to the camera, in this case the forehead and nose, and reduce what is furthest away.

How does distortion affect portraits?

The nearer the camera is to the subject and the shorter the focal length, the more distortion that will appear in the photograph. If the camera is at head height, the head will appear to lean into the photo – the forehead or nose will appear larger and the effect will be unnatural.

This wide-angle lens also offers a short telephoto range. In terms of digital use, it would work as a 27-83mm lens.

Tip

Instead of using an all-in-one super zoom, such as a 28–300mm lens, use two different lenses, such as a 28–100mm and a 100–300mm. This will get you a wider aperture at all focal lengths, which is better for portraits. Also, consider a 50mm, f/1.8 or f/1.4 lens – these are 'must-have' lenses for portraits.

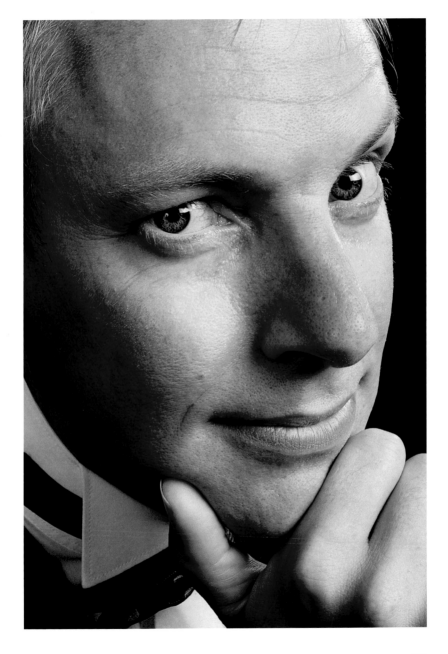

Can distortion be used for creative effect?

Yes, if you understand the effect it is going to have in the first place. For example, use a 28mm focal length and stand on a chair above the subject. Have them place their arms by their side and look up to the camera. The resulting picture will show a large head, tapering away to tiny feet – the subject will look like a rocket looming up into the picture. Shoot from floor level, and the subject will appear to be receding into the atmosphere. Have the subject sit on the floor with legs pointed towards the camera and the effect will elongate them.

Knowing the properties of the lens being used can lead to creative exploitation, as with this picture here. The hand placed right in front of the camera appears larger than the head.

What is a telephoto lens?

A telephoto lens is one with a focal length of over 50mm, typically around 100mm and upwards. A standard is the 200mm lens. Anything larger has a considerable reach and starts to be of less use in portraiture. A telephoto lens is also referred to as a 'long lens'.

Tip

Use wide-angle lenses when you want a creative effect or you have to get a large party into the shot.

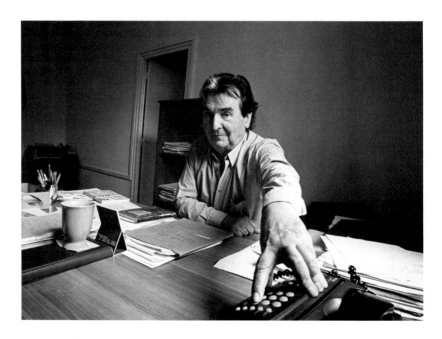

Does telephoto compress perspective?

It's a common assertion that telephoto lenses compress the perspective by making the subject and the background appear closer together. They don't. What the telephoto lens does is reduce the field of view considerably, bringing the subject and the background closer. The background can now be seen better and there is less background on either side. To prove this, you can take two photos, one using a wide-angle lens, the other with a telephoto. If you crop the wide-angle shot to show exactly the same amount of scenery with the subject at the same height as the telephoto shot, the distance between the subject and the background in both pictures will be exactly the same.

A 200mm telephoto zoom lens is fine for portraits as you usually aren't shooting from far away, unless during a sporting event. Even then, digital users will benefit from the focal length extension that turns the lens into a 300mm effective reach.

Using a telephoto lens for portraits eliminates distortion, produces less depth of field at the same aperture as a wide-angle lens and narrows the field of view, which excludes extraneous background detail. (Image by Brad Kim)

What are the advantages of using a telephoto lens?

The reason for using a telephoto lens is twofold. The longer the focal length, the narrower the field of view. This is useful for excluding the environment immediately surrounding the subject. You can, of course, walk closer to the subject, but you risk introducing distortion. Also, the longer the focal length used, the more shallow the depth of field. This is ideal for throwing the background out of focus. Patrick Lichfield was well known for his use of long lenses in portraiture for exactly these reasons.

What are the disadvantages of telephoto lenses?

The longer the focal length, the faster the shutter speed required to avoid introducing camera shake into the picture. A rough rule of thumb is to express the focal length as a fraction of a second. For example, in order to keep a 200mm lens steady and to avoid camera shake, you need to have a shutter speed of 1/200 sec. The other factor to consider is the aperture. The longer the focal length of the lens, the harder and more expensive it is to manufacture with a wide-aperture setting. While a 50mm f/1.8 lens can be quite affordable, a 200mm f/2.8 lens will cost a lot more. The situation is worse with zoom lenses where the widest aperture varies through the focal length: a 28–300mm super zoom may start at f/3.5 at the 28mm end, but at the 300mm end it is likely to be f/6.3. This reduces the amount of light coming into the camera and makes it harder to avoid camera shake.

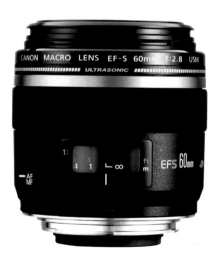

A macro lens might seem an unusual addition to the portrait photographer's armoury, but it can be used for interesting close-up shots.

What is a macro lens?

A macro lens allows you to focus on a subject and fill the viewfinder with a close-up shot. You might think that this is simply a case of using a longer focal length, but it isn't. A macro lens can zoom into a subject much like a telephoto lens, but it can then also focus on it, which is where the general telephoto lens fails. How large the subject appears on the image dictates the macro capability. If the subject appears life-size in the image, then the macro is said to be 1:1. If the subject is half its real size, the macro ratio is 1:2, and one third is 1:3. Some macro lenses have a short focal length to maximise depth of field, but these require the photographer to get very close to the subject. Others are more like telephoto lenses and enable the photographer to get close-up shots from farther away.

How can I use macro lenses in portraits?

While it might seem an unusual lens to use in portraiture, it can be applied for close-up abstract work, such as body parts. Macro lenses are very effective for capturing close-ups of the eye.

Are digital compact cameras good for macro?

While the digital compact is generally the poor cousin of the DSLR, there is one area where it can excel, and that is macro photography. There are many digital compact cameras that feature macro ability, which allows the camera to get as close as 1cm to the subject, offering reproduction ratios of 2:1 or better.

This shot was taken using a macro lens and places emphasis on colour and glamour, without revealing who the subject is.

Why is a flashgun better than the built-in flash?

There are a number of reasons why flashguns are better than built-in flash. Built-in flash uses the camera's own power supply, so heavy use will rapidly render the camera itself useless. As the power is much lower than that used by a dedicated flashgun, the distance covered by built-in flash is shorter and the time it takes to recycle and regenerate is longer – two or three times longer. Heavy-duty flashguns used in press photography can fire very rapidly (numerous times per second), while built-in flash can only fire every couple of seconds. With a flashgun, you generally get more control over how the flash is used and it also offers physical advantages. The light can be diffused more, it can be angled and bounced to avoid direct shadows, and because the light source is farther away from the lens, the chances of red-eye are significantly reduced.

What is red-eye?

Red-eye occurs when the flash hits the blood vessels at the back of the eye, which are in turn reflected directly back to the camera. This results in pictures where the subject has a red iris.

What is red-eye reduction?

In compact cameras, or with built-in flash on DSLRs, the flash fires spikes of light before the main flash goes off in order to cause the subject's pupils to contract, which reduces the occurrence of the red-eye effect.

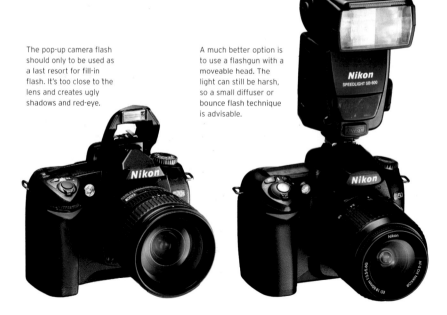

The pop-up camera flash should only to be used as a last resort for fill-in flash. It's too close to the lens and creates ugly shadows and red-eye.

A much better option is to use a flashgun with a moveable head. The light can still be harsh, so a small diffuser or bounce flash technique is advisable.

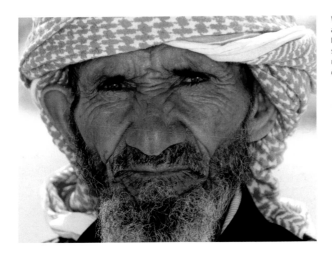

With a bright background and the subject's face hidden from direct sunlight, fill-in flash is required to avoid it being grossly underexposed.

What are guide numbers?

Guide numbers (GN) rate how powerful a flashgun is. It is calculated for the maximum working range of the flashgun at ISO 100. A guide number of 12, therefore, has a range of 12 feet at ISO 100. This is a typical GN for the flash of a compact camera. Note that the guide numbers are used to express imperial measurements. For a dedicated flashgun, the GN is more likely to be 30+, making the flashgun more expensive. Some flashguns can be fitted with additional battery compartments, increasing the power and reducing the recycle time.

What is TTL flash?

TTL stands for 'through the lens' and refers to the flash metering system. A manual flashgun simply outputs the amount of light that it is set to produce. It is down to the user to work out what this power should be and adjust the settings accordingly.

TTL flash, on the other hand, makes the process more intuitive by activating the flash and measuring the amount of light hitting the subject. When it thinks it has had the right amount, it turns the flash off. By setting flash exposure compensation, you can then use more or less flash than the system thinks is required for creative effect.

What is built-in flash best used for?

Built-in flash is ideal for those times when you can't use anything else. If the lighting is poor, the alternative is to use a wider aperture, increase the ISO rating on digital, or use a higher ISO-rated film. This is usually the case if flash is not allowed, or if it would destroy the ambient lighting. Otherwise, built-in flash can be used where quality is not a primary concern (parties, informal get-togethers). Built-in flash in SLR cameras can be used for fill-in flash where it supplements the natural lighting by filling in the shadows, rather than dominating the picture.

What is ring flash?

This is a flashgun with a circular flash head that fits around the lens itself. Generally much more expensive than regular flashguns, the ring flash is very popular in fashion and portrait photography because it provides an even source of light all the way around the outside of the subject.

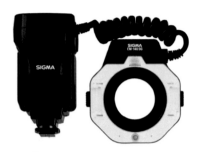

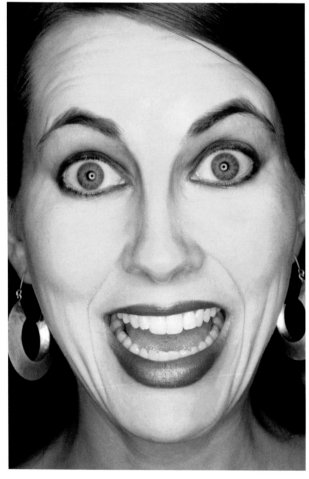

Ring flash differs from a standard flashgun in that the ring fits around the lens, giving an even spread of light with no shadows on the face.

The ring flash produces tell-tale catchlights in the eyes. It is still very popular in fashion and editorial portrait photography.

What are the two main types of artificial lighting?

The first produces a constant output (tungsten lamp), while the other provides light for a very short duration (electronic flash). With tungsten lamps, the photographer can see where all the shadows fall and meter the light with the camera. However, they have a lower power than electronic flash and they also tend to become very hot. On the other hand, electronic flash fires and illuminates the subject in a brief instant, and requires a separate hand-held meter to be used to detect the output. Some flash units come with modelling lamps that can be used to show where the shadows fall. A basic modelling lamp will simply show where the shadows are; a more sophisticated one will match the power of the flash and be capable of performing 'stepless' adjustments so that whatever setting the flash uses, the modelling lamp can give a fairly accurate rendition of it.

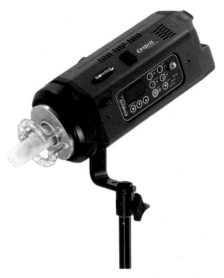

This is an electronic flash head with no diffuser. Electronic flash is calibrated to the same colour temperature as midday light.

What are the types of electronic flash?

There are two types of electronic flash. One is where the power transformer unit is built into the flash head, so that it simply needs connecting to a mains supply. The other type requires plugging into a power supply unit. The former is more affordable and more popular, while the latter is more expensive and better suited to professional use.

What are the advantages of electronic flash?

Electronic flash has two main advantages over tungsten lamps. Firstly, the colour temperature of flash is set to standard sunny daylight, which is calibrated to 5500K. This means that digital cameras and standard film will produce images without a colour cast. Secondly, it is generally more powerful, enabling a greater range of lighting to be combined and smaller apertures to be used on the camera.

Tip

Guide numbers for flash use imperial measurements. If you want distances in metric, you have to convert them.

33

Are tungsten lamps the same as household lighting?

No. Tungsten lamps may use a tungsten filament like the household bulb, but they are more powerful. They have a higher colour temperature of between 3000K–5000K, depending on the make. A household bulb has a colour temperature of around 2500K, which produces a warm, red-yellow colour cast.

If you don't use filters or adjust the white balance, a tungsten light source will give a yellow colour cast. This may work very well in certain types of images, giving them a warm, homely feel.

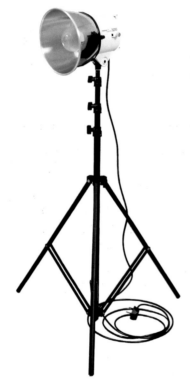

Tungsten lamps are cheaper than electronic flash, but they tend to run much hotter as they are on continuously. The advantage is that you can see clearly where all the shadows will fall. The disadvantage is that they use a much lower colour temperature.

What is tungsten best suited for, film or digital?

As tungsten lamps tend to be cheaper than flash, it's a more affordable entry route to dedicated lighting for the amateur. However, unless shooting on black-and-white film, tungsten lamps are harder work for the film user. Blue or magenta filters are required to counter the colour cast from the lamp. Alternatively, a tungsten-balanced film must be used; however, you must ensure that the colour temperature of the film is the same as the lighting. Digital cameras have a significant advantage with white balance control. Automatic white balance (AWB) will attempt to correct the colour temperature automatically, but it is worth noting that it is not infallible, particularly at lower colour temperatures. The answer here is to set the white balance manually and correct the colour cast. Simply, it is easier to use digital cameras when working with tungsten lamps.

What are the various types of flash diffuser?

Electronic flash in itself is very bright and casts hard-edged shadows on a subject's face, unless it is aimed directly at it. To spread the light out and make it softer, the flash needs diffusing. There are typically two ways of doing this. One is by using a softbox, which comes in various shapes and sizes. The other is by using an umbrella or a 'brolly'. Softboxes are usually square, but the large ones can be octagonal; specialist designs for vertical strips of light are rectangular. Usually, light is fired through the softbox and bounced back from the brolly. You can also fire the flash through the brolly for a much weaker effect.

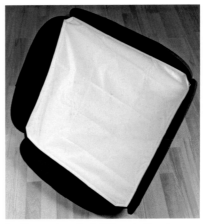

A softbox creates softer light than a brolly and gives less harsh shadows. The bigger the softbox, the more diffused the light.

Which is better, softbox or umbrella?

The softbox is usually more expensive, but it does a better job of creating softer light. However, the brolly is more portable, faster to set up and can be used to tint the image if the light is fired through it. You'll often see brollies being used in shopping malls and quick-turnaround photo sessions in shops because of their smaller size and portability. You are more likely to find softboxes in studios where they can be left fully constructed, and there is more room available to accommodate them.

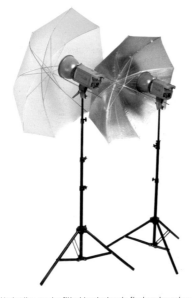

Umbrellas can be fitted to electronic flash or tungsten lamps and work by reflecting the light backwards. Different colour umbrellas can tint the light and you can also fire the light through the umbrella for a very diffused and weak effect.

Tip

The more powerful an electronic flash head, the faster it will recycle between shots and the more light it can generate.

35

What is a reflector?

Quite simply, it's something that reflects light. It can be a commercially available reflective square, circle or set of triangles, or it can be something as simple as a piece of white card. You can even use white walls as impromptu reflectors, bouncing light off them and on to the subject.

Why do I need a reflector?

The reflector is there to provide fill-in light, usually on the far side of the subject, facing the light source it is reflecting. Reflectors have many uses. They provide gentle light in the studio where they bounce back light from the main light. Outdoors, they lessen shadows or enable you to shoot in bright sunlight. The reflector can bounce light back on to the subject's features, especially when shooting with the sun behind the subject.

Reflectors are handy for images where bright light is coming from behind the subject. To avoid underexposing the foreground or overexposing the background, use either a flash or reflector to achieve a more natural result.

Reflectors come in various sizes and shapes, but the most common are round and white. A gold reflector will warm up the image.

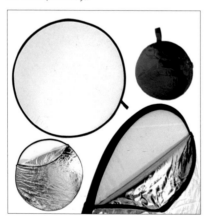

Tip

The more the light source is diffused, the softer it becomes and the weaker it gets. This can lead to the use of wider apertures and you must ensure that ambient light doesn't become a factor.

What are snoots, barn doors and gels?

These are all items that replace the brolly and softbox and provide alternative methods of modifying the shape, form and colour of the light from the flash head. Barn doors are a set of four independently movable shutters that can be used to control exactly where the light falls, but result in a very hard edge. A snoot is a cone-like device that provides a narrow point of light and is usually used to light hair; it can also be used for spot effects. There are other light modifiers such as the honeycomb, which provides patterned light effects. There are also coloured gels that fit over the light and provide coloured effects. Digital users need to ensure that the white balance is set manually when using gels otherwise the camera may detect it as a colour cast and try to cancel it out.

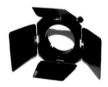

The barn door gets its name from having large closing shutters that can be used to narrow the illuminated area, giving a sharp transition from light to shadow.

Backgrounds either come on a roll on a frame system or are fastened to the framework. An alternative is a portable background which expands and can be easily taken to locations.

The snoot is used to provide a very narrow beam of light. It is used for highlighting small areas, producing spot effects and, most commonly, as a hair light.

What do I use for backgrounds?

The Edwardians were the champions of the studio background, offering everything from woodland scenes, country houses and Egyptian settings as backdrops. These days, you are more likely to find plain, coloured fabrics suspended on a background pole system. Traditional patterned fabrics are also available but can look quite dated. Alternatively, digital users may wish to shoot against a white background and drop in a different background later by using photo-editing software.

37

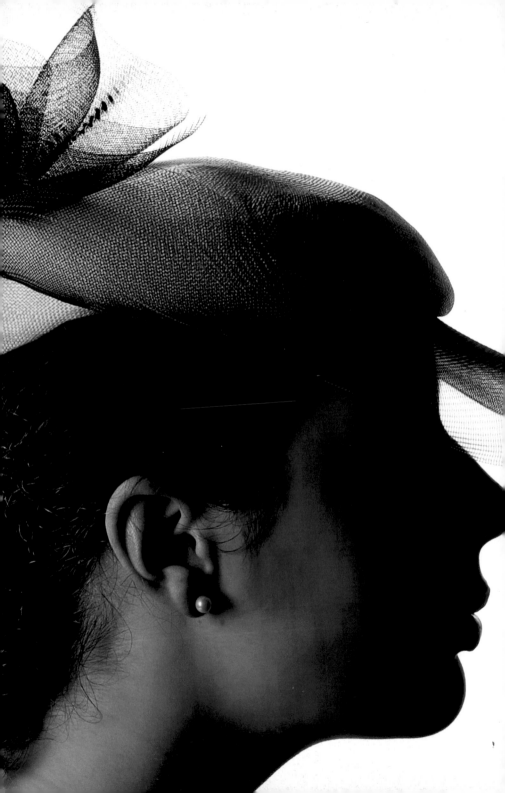

SECTION TWO

METERING

Metering is the method by which the exposure value of an image is determined. In any given scene, there is a range of light from dark to bright - it can be gloomy or well-lit, with limited or extreme contrast. The recording medium of the camera can only capture a certain range of brightness so the job of metering, whether in the form of a hand-held meter or one that is built into the camera, is to determine what value would best represent the middle tone of brightness in the image. Once the middle tone is set, the light and dark tones around it are captured by the camera.

Accurate metering, whether in the studio or on location, helps to create the mood and feel of an image.

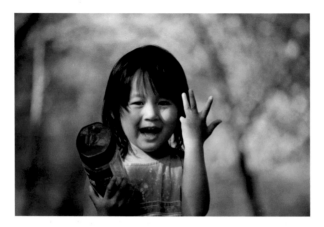

A pattern of direct sunlight falls on the child, filtered through the trees, while the background is ambient light. Only the tree to the left in the background is directly lit by the sun.

What is the difference between ambient and direct lighting?

For a very thorough and technical exploration of metering, please refer to Chris Weston's excellent Exposure book, which is the first in this series of Photography FAQs. However, there are a number of portrait-orientated issues that merit explanation here. Ambient and direct lighting are generally referred to together since the definition of a particular light source changes depending on how it is used. Simply, ambient light is the background light in a scene whereas direct light is a light source used to illuminate something specific, such as the subject in a portrait. For example, a lamp that is placed in the foreground of a portrait becomes the main light source, which casts light and shadow on the subject. The rest of the room may be illuminated by window light. The lamp is the direct lighting source and the window light is the ambient light.

Why differentiate between ambient and direct lighting?

This determines what you are metering and exposing the photograph for. Usually, it's the direct lighting source, but when flash is involved, it is sometimes desirable to create a combined exposure that also records the ambient lighting. This will be discussed in more detail in Section Four: Natural Lighting and Supplementary Flash (page 62).

What is the point of metering?

The aim of all metering systems is to produce an exposure where the middle brightness value of the scene being metered is converted into 18 per cent grey. This can be tricky to understand but it essentially means this: the output, whether on film or digital, is a picture whose tones range from black, through various shades of grey, to white. An 18 per cent grey shade is said to be the midpoint between black and white. No matter how much brightness there is in the scene, it all has to fit into the range of black-grey-white.

The purpose of metering is to work out a value (from the scene itself) that is the midpoint of the range of tones being metered, which can then be converted into the midpoint in the output. This value is known as the exposure value (EV).

What does metering do with the exposure value (EV)?

The exposure value is a number that expresses brightness – the higher it is, the brighter the scene. The typical EV range is -3 to 23. The metering indicates what exposure value is required, and then, depending on the metering mode being used, this is converted into aperture and shutter speed settings. The aperture and shutter speed settings are reciprocally linked – if one is increased, the other can be decreased, so that the same exposure value is retained. For example, let us take a portrait metered at f/8 at 1/60sec. For portraiture, we want to use a wider aperture to lose the background. Hence, f/5.6 at 1/125sec, f/4 at 1/250sec and f/2.8 at 1/500sec all give the same exposure, but f/2.8 can be selected with a faster shutter speed in order to lose depth of field.

Here, light falls on to the subject, where it is measured by a hand-held meter. The values obtained are then entered into the camera in manual mode. This is normal practice in the studio.

How can I tell what shutter speed and apertures are derived from the EV?

Normally you won't have to. The metering of the camera does the job for you. The only time there's an exception to this is when a hand-held meter gives a value in EV rather than apertures and shutter speeds. Even then, there is almost always the option on the meter to convert the reading.

What is the difference between reflected and incident light?

Light that falls on to a subject is incident light and this can be metered with a hand-held light meter. This is applicable to both portrait and landscape photographers as it gives an accurate rating of the actual light level hitting the subject; it is not affected by how reflective or light/dark the subject is. Reflected light is the opposite – it is the light reflected off the subject, which is metered by in-camera metering.

Reflected light is bounced off the subject from the light source and can be metered directly by the camera itself using a programmed mode.

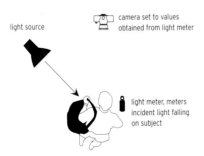

light source

camera set to values obtained from light meter

light meter, meters incident light falling on subject

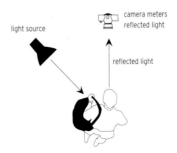

light source

camera meters reflected light

reflected light

What is dynamic range?

This is the brightness range that either film or sensor can record. Note that this is a fixed range, not a fixed exposure. Once the scene has been metered, the range is set with the midpoint locked to the value that the metering has registered. Any tone darker than the lowest level of the range is rendered as completely black and any tone brighter than the highest level is rendered as completely white. For film photographers, there is the choice between negative print film and positive slide film. The former has a distinctly wider dynamic range than the latter, but is of lower quality. For digital users, the dynamic range is more akin to that of slide film and sensors are very susceptible to losing white highlights in sunlight. It is often better to underexpose an image to retain the highlights than to shoot what looks like a perfect exposure, but with blown highlights. Underexposed images can be adjusted later in the process.

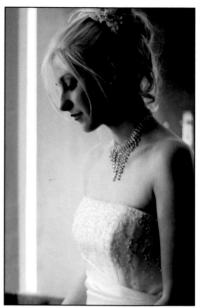

Zone metering was used in this image in order to have the left side of the picture in brightness and the right side fade towards darkness. As the actual window isn't in the shot, there's an even range of tones that is ideal for zone metering.

What are the main metering modes?

There are three main modes: zone, spot and centre-weighted metering. Zone metering splits up the scene into nine or 27 zones and assesses an exposure value for each one. It then averages them out to form an overall EV rating, which is then translated into the aperture and shutter speed. Spot metering takes a small circular area at the centre of the screen, usually around three or six degrees, and assesses the exposure for the specific spot only. Centre-weighted metering is a combination of spot and zone metering. The system of nine or 27 zones are read to produce an overall exposure value. The spot meter reading is taken at the same time and the two values are averaged out.

Tip

In challenging lighting conditions, use spot metering mode and look for the area that should come out as the mid-tone in the image. Spot meter from there.

See also

Why are white clothes and blonde hair burnt out in sunlight when shooting digitally? (p49)

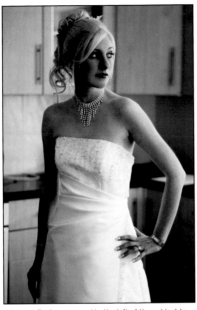 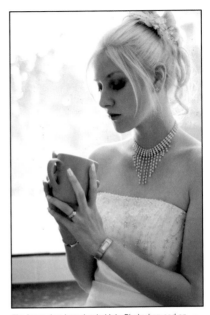

A large reflector was used to the left of the subject to bounce light back on to the side, which would otherwise be in dark shadow. Centre-weighted metering was used from this side, leading to the light falling from the right side, and forming pleasing highlights.

The image has been loaded into Photoshop and an area on the cup was spot metered. Look at the histogram of this area in the palette on the right of the bottom image. It's almost dead centre.

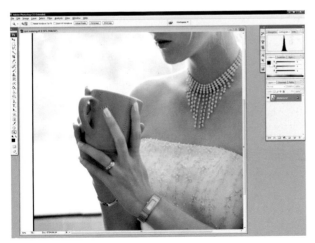

The cup in the woman's hands was close to being a pure red colour, so I spot metered from this, knowing that the subject would be brighter, and that the window light would form a halo of brightness. Zone metering would have been heavily influenced by the window, resulting in the subject being in dark shadow.

12 | EXPOSURE COMPENSATION AND BRACKETING

What is exposure compensation?

As previously discussed, the purpose of camera metering is to arrive at an accurate exposure by setting aperture and shutter speed values. Exposure compensation allows the photographer to increase or decrease the exposure through a simple control. This is usually available in one-thirds of an exposure stop or an exposure value (EV). Regardless of the camera mode (Program, Scene, Shutter Priority or Aperture Priority), simply setting positive exposure compensation will make the image brighter and vice versa. It's important to realise that it won't make the picture necessarily dark or light, but darker or lighter than it would have been if you hadn't used exposure compensation. If you are using Aperture Priority mode and exposure compensation, the camera will adjust the shutter speed accordingly. If you are using Shutter Priority, it will adjust the aperture. The camera can adjust either the aperture or the shutter if you are in Automatic mode.

Several things could go wrong with the exposure here. The face and jacket are lit by bright sunlight, but the rest of the figure is in shadow; the deep blue sky is open, allowing lots of light. Exposure compensation might be used to retain highlights or brighten the shadows.

When would I use it?

Certain types of scenes are guaranteed to fool regular zone metering systems. By knowing this, you can anticipate what will happen and dial in exposure compensation first. Or, you can simply check the results on the screen of a digital camera and make a very easy adjustment with exposure compensation. Very white scenes such as snow will cause underexposure because the camera will attempt to render the snow as the midpoint, which is grey. Hence without exposure compensation, a white, snowy scene will come out grey and underexposed. Here, positive exposure compensation would be used, perhaps +1EV or +2EV. However, digital users must bear in mind the risk of losing the highlights.

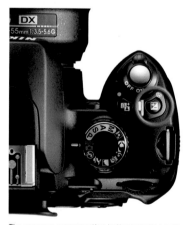

The exposure compensation button usually has the plus and minus symbols on it. On a DSLR, it can be used with a command dial to change the exposure.

Equally, a scene featuring dark colours would fool the metering system into overexposure as it seeks to render the black colours as grey. Here, negative exposure compensation would be used.

Can exposure compensation be used for creative effect?

Certainly. If you want the mood of a picture to be deliberately bright or dark and gloomy then exposure compensation could be used to force the image brighter or darker.

What is bracketing?

Bracketing is the use of exposure compensation to cover all bases. Instead of having one picture taken, the camera is set to bracket an exposure with either one or two settings on either side of the nominal exposure. This means that the initial result could have a minimum of three images. The first is underexposed, the second is the nominal exposure, while the third is overexposed. If the camera is set to use two bracketing values of say, 1EV and 2EV, then there will be five images: -2EV, -1EV, the nominal exposure, +1EV and +2EV.

This picture is a riot of contrast. There's a dark background, bright sunlight, wispy white hair, half the face in the light and half in shadow. Bracketing allows the photographer to capture the best possible shot.

When do I need to bracket?

Since lighting is either changeable or results in high contrast, judging the exposure can be difficult. Bracketing allows the photographer to judge exposure more accurately. If the subject is moving or the shot cannot easily be set up to be repeated using different settings – a winner coming to a podium to collect a trophy, for example – then bracketing will capture a clutch of exposures from a single press of the fire button, and then it's up to you to pick the best one.

By adjusting the overall exposure to correctly record the subject's face, the backlighting caused the hair to burn out in a blaze of light.

See also

Metering challenging lighting (page 49)

45

What are high-key portraits?

Quite simply, a high-key portrait is one in which the majority of the tones in the image are concentrated on the lighter side of the midpoint, towards the white point. The aim of the high-key image is to give a feel of lightness, beauty, airiness, delicacy, fragility and purity.

With an overexposed background rendered as white and a light foreground, this image was conceived for a high-key effect.

How easy are they to shoot on digital and film?

High-key images are relatively easy to capture on negative print film as it has such a wide tonal range. However, it is more difficult to shoot on positive slide film and digital where the tonal range is far less. The problem comes with the fact that metering will tend to render a white scene as grey, so the photographer needs to manipulate the exposure to get the whiter, lighter tones. On slide film and digital cameras, this pushing of the tonal range comes dangerously close to blowing out the highlights. When shooting high-key images, care needs to be taken and, in the case of digital, a careful scrutiny of the histogram or white points on the playback should be done to check that desired highlights are not lost.

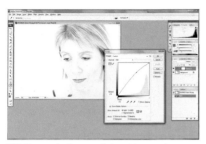

With the use of a Curves adjustment layer, an image can be made as bright as you like, with the layer mask being used to retain important detail.

Can high-key images be produced using photo editing?

Yes. However, better images will be produced if the original image is light to begin with. If the original image is dark, pushing the image into the bright end of the tonal range will expose variations in tone and enhance any noise that is in the image.

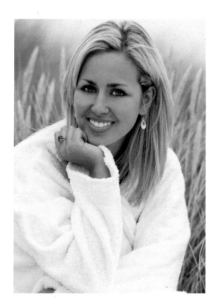

How do I meter predominantly white portrait scenes?

If a scene largely consists of white or light tones, then zone metering will underexpose and turn it grey. To make the scene lighter, zone metering can be used with +1EV or +2EV exposure compensation to brighten the result. An alternative is to use a hand-held incident light meter, rather than rely on the camera's reflective metering system, to assess the light falling on the subject. This way, the metering will not be fooled by the expanse of white and will be set according to the actual light landing on the subject. The white tones will then render properly.

If the shot is taken in the studio using electronic flash, then it is also possible to set the aperture at a wider setting than the one metered, which will make the image brighter. For example, the key light from the flash falling on the subject is metered with a hand-held meter at f/8. If the camera is set to one stop brighter at f/5.6, then the subject is overexposed and will be correspondingly brighter as a result.

This image is predominantly light, but would be underexposed using zone metering. Care must be taken when adjusting the exposure so as not to go too far and start losing highlights in the white areas.

See also

Exposure compensation and bracketing (page 44)

Low-key images can suggest excitement and danger; they are ideal ways to represent dramatic productions.

What are low-key portraits?

These are images where the tones are predominantly towards the black point from the midpoint. A low-key portrait suggests drama, danger and excitement. A brightly lit subject surrounded by shadows is not necessarily a low-key scene. However one in which a portion of the body or the background is dark, along with everything else in the picture, is a low-key portrait.

Why is my low-key portrait all muddy?

Zone metering is designed to find the grey mid-tone in an image and render accordingly. Like high-key images, if the tones are at one end of the spectrum, it will see the limited range and render the middle tone out of it as grey. If the image is low key – rather than just having some shadow – then the metering will turn dark shadows into muddy greys.

How do I meter to achieve a low-key image?

Exactly the same as with a high-key image, but where positive exposure compensation is used, replace with negative exposure instead. When it comes to using studio flash, the aperture would be increased. For example, the original metered f/8 scene would be set to f/11, which would make it darker.

There are two other points worth noting: there is generally more detail in digital images at the darker end of the spectrum, and many digital cameras produce noise in the shadow areas. Each is not in itself a problem, but if you need to brighten up dark areas, the noise will become more evident.

Certainly it's also much easier to turn a regular scene into a low-key one with the aid of photo-editing software. With just a few layers, the light can be reduced, masked and turned down where required, resulting in no increase in noise or degradation of image quality.

This image has been deliberately underexposed to emphasise its low-key nature. A black jacket against a black background complete the gloomy aura.

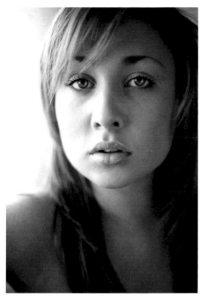

This is a tricky shot to meter because the light is very strong to the side and back. It's coming from a long, large window, which would have left the right side of the face very dark. A reflector has been used to bounce light back in. Spot metering has also been used and focused on the cheek on the right, adjacent to the nose, as this is the mid-tone in the image. This results in the left side becoming bright and overexposed.

Why are white clothes and blonde hair burnt out in sunlight when shooting digitally?

The problem here is not one of metering as such, because the rest of the picture is likely to be perfectly well exposed. The burn-out is caused by the reflectivity of the white and blonde elements and how sensitive digital chips are to these tones. The light reflects significantly more from these elements, requiring a significantly wider tonal range to capture all the tones. Digital has a limited tonal range and, as a result, the very bright tones are lost and represented as pure white.

How do I capture white clothes and blonde hair in sunlight?

A problem exists because the tonal range of the scene far exceeds what the digital camera can capture. Slide film users would have a similar problem. As suggested in the previous chapter, one solution is to use a hand-held light meter and to meter the light falling on the subject itself. This may or may not be sufficient, though. The camera can be put into spot metering mode, and the spot focused on the area of clothing or hair that is in bright sunlight. This will read the very bright spot that would otherwise burn out and set the exposure to be the centre of the calculation. That, of course, will be significantly underexposed because the very bright element will be rendered as the mid-tone. So, and contrary to what you might intuitively think, dial in +2EV to make the image brighter. Remember: you are making the image brighter, not because it's already bright, but because the spot metering from that bright point will make it underexposed.

An alternative is to recognise that the scene contains highly reflective elements. Use zone metering with negative exposure compensation in order to drag the overall exposure down.

In both methods, it is important to avoid losing the highlights that are so reflective in sunlight. It has to be accepted that unless you can move the subject out of the sun, or add light to the rest of the subject and thus reduce the contrast, some underexposure in the rest of the picture is inevitable because of the large amount of contrast in the scene.

How do I meter backlit scenes?

A backlit scene is one where the light source, natural or artificial, is behind the subject. If you do not use a flash or a reflector, zone metering will invariably result in the subject being underexposed. There are two ways to go from here. Either try to create a silhouette (see next question) so that the subject is just a shadow against the light, or meter for the subject and expect the background to disappear into a bright blaze of light.

To meter for the subject (which is already in shadow), use spot metering which places the subject in the middle of the exposure range, and then +1EV or perhaps +2EV to make them brighter. Expect to see the background disappear if shooting digital or slide film. Centre-weighted metering could also be used, which will read the spot in the middle and then the background, and put the result in the middle of the exposure. This will make the subject appear darker than if just spot metering were used, but it will retain more of the background light. Consequently, a more positive exposure compensation will be required to make the subject brighter. It all depends on how much background detail you want at the expense of the subject being darker. Digital camera users should check the highlights on the playback, as well as the histogram, in order to see the results and then alter the exposure compensation accordingly.

The use of silhouettes results in a very graphic image, particularly when set against strong colours, as in this image.

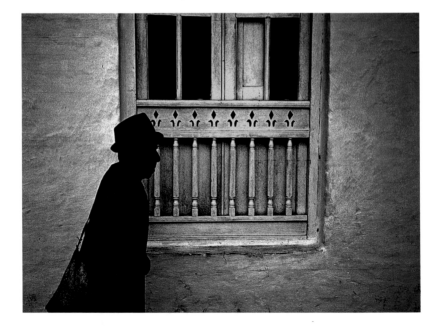

How do I create a silhouette?

Zone metering can be used to create a silhouette. An exposure compensation of -1EV should ensure that the subject becomes a silhouette, but this largely depends on exactly how bright the background is. If conditions are bright and sunny, then probably no exposure compensation will be required. If the source is simply bright light, then some may be needed.

Why would I use flash with backlighting?

The simple answer is to even up the lighting in the foreground and to match the lighting in the background. This allows for the capture of both subject and background light, and not having to pick one over the other.

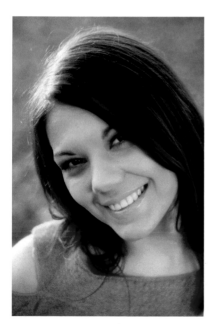

How do I use flash with a backlit scene?

Firstly, take a meter reading of the background light. This is your basic exposure, which could be f/5.6 at 1/500 sec since it's bright. If the flashgun is manual, then you need to set the power appropriately, incorporating the subject distance, so that it matches the background.

Whether the flashgun is manual or automatic TTL, you need to know at what speed the flashgun will synchronise with the camera. Some combinations can work at high speed, others won't work at more than 1/60 sec. If that's the case, then you need to work out what aperture to set to create an exposure that is the equivalent to the background reading. 1/500 sec at f/5.6 is the same as 1/250 sec at f/8, 1/125 sec at f/11 and 1/60 sec at f/16. Therefore, the camera needs to be set to use the flashgun at 1/60 sec, which is the flash-sync speed at f/16 aperture.

Let's go back to our manual flashgun. As f/16 therefore becomes the power setting for the flashgun, you need to work out the distance to stand away from the subject. Using the flashgun formula of:

f-stop = Guide Number / Distance to subject

it can be turned into:

Distance to subject = Guide Number / f-stop

Hence, a flashgun with a GN of 56 and an f stop of f/16, means that the flashgun should be situated around 4.5 feet from the subject.

Here is another backlit image, but this time the flash has been used to render the face at almost the same brightness. It's actually slightly darker than the backlighting, but the metering has been set for the face itself so that it is correctly exposed and the light hitting the hair now forms a bright highlight.

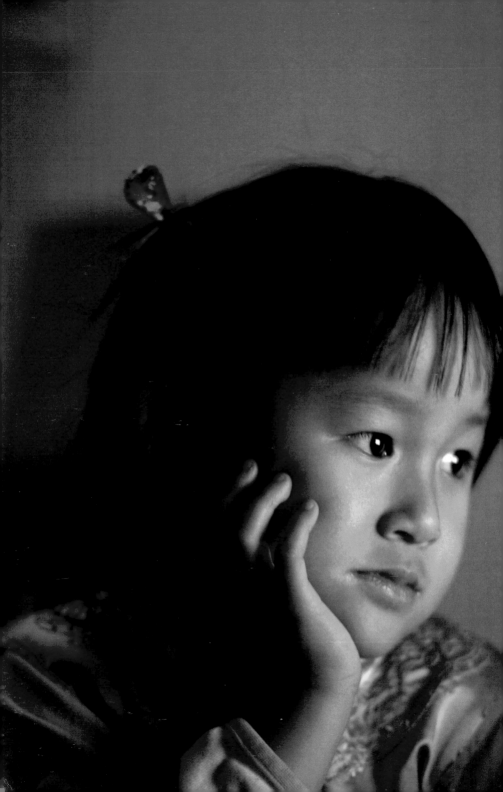

USING COLOUR AND MONOCHROME

There are two aspects to colour when discussing portraits. The first is the colour temperature of light, which affects how the image is recorded and portrayed. This involves film, white balance settings and filters. The second is the use of colour itself: the language of colour and what predominant colours have to say in an image. Both black and white denote the absence of colour and it is necessary to touch on this when discussing colour.

Colour can be used to set the tone and mood of a photograph or to complement the style and emotion shown.

What is colour temperature?

In photography, colour temperature is a characteristic of visible light and is related to the surface temperature of the light source. Colour temperatures are measured in degrees Kelvin (K) and start with red at around 1800K – the lowest colour temperature. It then progresses through to yellow (3,000K–4,000K), white (approximately 5,500K), cyan (8,000K–12,000K) and then blue (16,000K) – the highest colour temperature. This contradicts the usual colour associations that link red with fire and blue with cold, such as water and ice. Some digital cameras will show the Kelvin scale for adjusting colour temperature, while all compacts and some DSLRs will simply use illustrations of conditions.

dawn early morning mid morning around noon mid afternoon late afternoon dusk

The colour of light changes throughout the day, rising from red to blue then white, and then back down to red. Other factors, such as clouds and brightness, affect the colour temperature as well.

What is the colour temperature of daylight?

This changes throughout the day, even though the actual temperature of the source – the sun – does not. This is due to the refraction of the light through the atmosphere and, to a lesser degree, the scattering tendencies of light, which scatters more blue than red. At sunrise and sunset, the colour temperature of daylight is at its lowest, which means more reds, oranges and a temperature of 2,500K–4,500K. Towards midday, with a clear sky, light appears white at around 5,500K. This is the colour temperature that standard film is calibrated to. Under an overcast sky, colour temperature can rise to 8,000K. In shade and under a blue sky, colour temperature can be 10,000K and higher.

What are the colour temperatures of artificial light sources?

An ordinary domestic tungsten light bulb has a colour temperature of only 2,500K – this is why an unadjusted image shot indoors will give the subject a red or orange colour cast. Stronger photoflood bulbs can have a temperature of 3,500K, while a dedicated high-power tungsten lamp can raise this further to 4,000K–5,000K. One of the main advantages of electronic flash is that it has a colour temperature of 5,500K – the same as summer daylight or white.

The colour temperature chart shows typical temperatures for light sources, both artificial and natural.

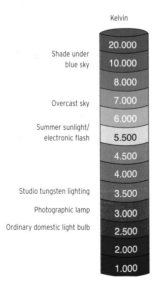

Kelvin

	20.000
Shade under blue sky	10.000
	8.000
Overcast sky	7.000
	6.000
Summer sunlight/ electronic flash	5.500
	4.500
	4.000
Studio tungsten lighting	3.500
Photographic lamp	3.000
Ordinary domestic light bulb	2.500
	2.000
	1.000

What is AWB on digital cameras?

AWB stands for automatic white balance. It is an automatic process of detecting colour temperature and adjusting the colours accordingly so that any white surfaces or subjects are rendered as white, which also then cancels the colour cast over the rest of the image. You can manually select a white balance setting by either using a picture symbol that corresponds with the lighting conditions or using a specific colour temperature setting – this is usually available on high-end cameras rather than compact ones.

When should I turn AWB off?

As AWB is less accurate at extremely low or high colour temperatures, it is best to set it manually in these situations. Also, cameras are likely to see the golden colours of sunrise as a colour cast and try to cancel them out when the effect is usually desirable, even in portraits.

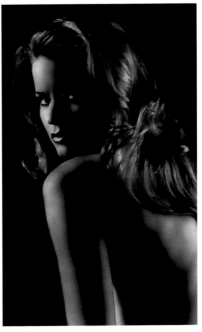

The white balance controls on digital cameras can be used creatively in order to warm up or cool down an image.

White balance settings to control and counter colour temperatures are normally in the menu system of most digital cameras. Top-of-the-range DSLRs will have better and more dedicated control offerings. Film users have to make do with cumbersome filters.

Can white balance be used creatively?

Yes – it's the digital equivalent of using filters. Setting a lower colour temperature on the camera than that of the actual lighting conditions will make the image cooler or bluer, while setting the colour temperature higher than the actual conditions will make it warmer or redder. It's important to realise that white balance adds colour to counteract and cancel out colour variations from white. So, knowing that a high colour temperature in itself is blue, setting the camera to that temperature actually means adding the red-orange end of the spectrum to cancel the blue and make it white.

What are Wratten filters?

Wratten numbers and filters are a method of labelling that describes what type of effect the filter has. Frederick Wratten and CEK Mees sold their company to Kodak in 1912, and Kodak continued to produce Wratten filters so that the numbers that were originally nominated became synonymous with the effects. The 81 Series, for example, is famous as a warming filter that adds pale orange to an image. While many of the filters just have one number, others also have letters that denote increasing strength or a higher range. Other companies produce filters with Wratten-designated numbers, but the process they use is different – only the effect is similar. Other companies use different labelling methods altogether.

This colour chart shows how the three primary RGB and three secondary colours are related. To cancel out a blue cast, add a yellow filter; to counteract the green of fluorescent lighting, add a magenta filter.

How can I correct colour casts when using film?

When using film, colour casts can be prevented by using a coloured filter that fits over the camera lens. As previously discussed, light has a colour temperature and, unless you are shooting in the middle of the day or under studio flash lighting, will have a colour cast that will be recorded on the film. If you look at the colour wheel, you can see it contains three primary colours in the RGB model – red, green and blue. Add combinations of these to get the secondary colours of yellow, magenta and cyan. If conditions are going to produce one type of colour cast, simply look across the wheel to find the colour that balances it.

The most common colour casts come from tungsten lighting. This is usually red-yellow, which requires a cyan-blue filter. Fluorescent lights tend to have a green cast and a magenta colour filter can be used to counter this. Snow in shade will often have a blue cast and a yellow filter will balance this out.

This is a neutral-density filter in a filter holder, which screws to the front of the camera lens. It is useful for reducing light to get wider apertures in portraits.

Do I need colour-correction filters when using digital?

No. This is the job of the AWB and the manual white balance settings, as discussed in the previous topic.

What kind of filters are useful for portraiture?

Aside from the colour filters for casts and warming up images, there are filters that are useful for both film and digital users. One filter used universally is the 1A Skylight filter that absorbs ultraviolet radiation, which causes haze. It is mainly used in landscape photography, but as it has no effect on the colour or strength of visible light, it is often used permanently, particularly as it usually comes in the form of a screw fitting that covers the lens. In effect, it then becomes a permanent lens protector.

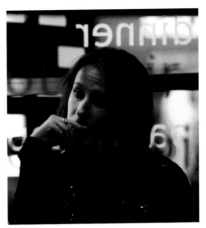

A polariser is a useful filter because it can block certain wavelengths of light. In practice, this means that it can remove reflections from glass, allowing you to photograph what is on the other side. The only downside is that it reduces the light coming into the camera by one or two aperture stops.
(Image by Brad Kim)

Another filter is the neutral-density filter, which comes in a variety of strengths that are labelled according to how many f-stops of light they block out. Indeed, the purpose of the filter is to reduce the amount of light coming in, without colouring or affecting the image. This can be useful if you want to combine the subject with a moving background so that the background becomes blurred. It can also be used on bright days to reduce the ambient lighting.

In the old days of film, the soft-focus filter was a popular choice. These days, if shooting digitally, it's usually better to shoot normally and add the soft-focus effect to specific areas of the image later when processing on the computer.

The other filter worth mentioning for both film and digital photographers is the polariser. Polarisers block out certain wavelengths of light and can be used when shooting through glass or water

to remove reflections. It is important to note that the polariser has to be rotated until it negates the elements of unwanted light. It will also make the colour stronger in the case of film, and darker in the case of digital. As well, because light is being blocked out, it will reduce the level by one or two f-stops. Modern cameras with metering will take care of this, but the loss of light can cause camera shake if it becomes too dark. If using a manual camera, such as a medium-format model, you must take note of the reduced light level in your calculations when using a hand-held light meter.

See also

Colour temperature (page 54)

57

What do different colours say in a portrait?

Colour choices play a key part in setting the mood and tone of a portrait. Simply shooting someone in everyday clothing against the backdrop of their lounge will result in an image that largely only has value to a limited personal audience. Colour co-ordinate the scene and you can create themes and feelings that have something to say to everyone.

While different colours suggest different things depending on culture, background and location, there are some that generally hold true across the board. Red is the most dramatic colour, suggesting love, sex, romance, passion, anger, fire and war. Blue is the most soothing, conveying calmness, tranquillity and peace. Green, having been commandeered by environmentalists, suggests nature, goodness, growth, spring and life. Yellow and orange promote happiness, purple offers loftiness and royalty, while terracotta and brown suggest earthiness, autumn and reliability. Black and white, the two non-colours, equally have their part to play in this cavalcade of meaning. Black represents for sexiness, class and style, as well as depression and doom. On the other hand, white suggests purity, hope, virginity, snow and winter.

Any portrait containing a significant amount of any single colour will lend the meaning of that colour to the picture. If this is then tied into the character of the subject, it can present a very strong message.

This shot (left) was designed with the subsequent toning in mind so that the sepia-brown colour fits in perfectly with the country, rustic aesthetic of the location and outfit.

Yellow (above) is normally a happy colour and benefits from being well saturated. Otherwise, it loses its appeal rapidly. Combine it with a smiling or laughing subject to maximise the effect.

How can limiting the colour palette be effective?

Having read the previous two questions you're probably eager to start heaping on the colour. However, it can be extremely effective to use just one main colour in a portrait set-up and offer subtle shades of it. This will give the image subtlety and style. Pastel colours work very well for this approach, particularly for shots at weddings.

Using a limited or muted colour palette can be extremely effective in wedding photographs. This image (left) features pale green and blues.

Black and white, although not actual colours, can be used effectively on their own or in combination for a classy finish (below).

How can I make a simple scene more dramatic through the use colour?

Add accessories or background detail containing one dramatic or large-scale use of a single colour. In this way, the lack of décor or simplicity of the arrangement is given a dramatic boost through the use of one colour, which then focuses the attention or lends meaning to the scenario. The trick is not to detract from the subject.

Tip

Colours can mean different things to different cultures. Before embarking on a colour scheme, ensure that it is appropriate for the culture and audience the image is aimed at.

What subjects are best shot in black and white?

While there's a case for saying that you can shoot any portraits in black and white, there are certain types of images that benefit from certain styles of black and white. The most obvious is the weathered face of an elderly person, shot either with high-contrast, black-and-white film or manipulated on the computer to accentuate all the facial lines and features. Lifestyle images with fine monochrome tones are worth pursuing, and weddings are a staple diet of the monochrome photographer. Shooting or producing monochrome pictures strips away the visual language and meaning of colour, leaving only form, lighting and composition. Black and white is also suited to abstract work, which can include people and body parts, where texture and lighting become paramount.

Without the distraction of colour, black and white can convey emotions and at times lend a more periodic and historic feel.

Is it best to use the black-and-white mode on a digital camera or to convert it later?

There's little difference between shooting digitally in colour and shooting in black and white. The camera takes the picture in monochrome anyway and uses overlaid colour filters on the CCD/CMOS chip to work out the colours that go with it. Shooting in monochrome to start with simply eliminates all the colour processing. However, it's better to shoot in colour because you will have a colour original, and you can process the black-and-white image however you choose. As well, it is handy to have a colour version to fall back on in case the image doesn't look as good in black and white.

How do I bring out texture?

As texture is one of the key elements in some forms of monochrome photography, it makes sense to accentuate this feature. You can do this by ensuring that the light source for the portrait is as side-on as possible. It doesn't matter which side or position, as long as it's as far away from the target area as possible. Direct lighting will tend to flatten the texture, while side lighting will enhance and reveal it.

How can I get that grainy film look using digital?

Post-processing is required for this look, although many will still say that you can't really get the effect of grainy, high-speed, high-contrast, black-and-white film. However, there are now plug-in filters available for Photoshop that emulate different film stocks, including the large-grain ones. Otherwise, the digital user must look towards adding the various types of grain available in the photo-editing package and significantly increase the contrast to get a similar effect.

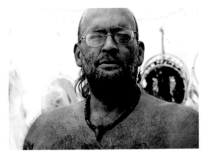

Tip

*Just starting out in portraits?
Try black and white first because it
concentrates on composition and
lighting, while excluding the
distractions that colour brings to
a photograph.*

This is the original sepia-toned image.

To add grain and contrast to the original image, a
duplicate layer was created and the Filter > Texture >
Grain filter run, using high-contrast grain.

The grain effect is multicoloured so the blend mode of
the layer was set to Luminosity, ignoring colour and
just applying tone. A layer mask was used to bring back
areas that were too dark or had lost a little detail.

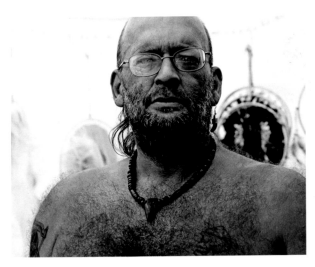

This alternative image
contains higher contrast,
with a smattering of
grain effect that
complements the
subject matter.

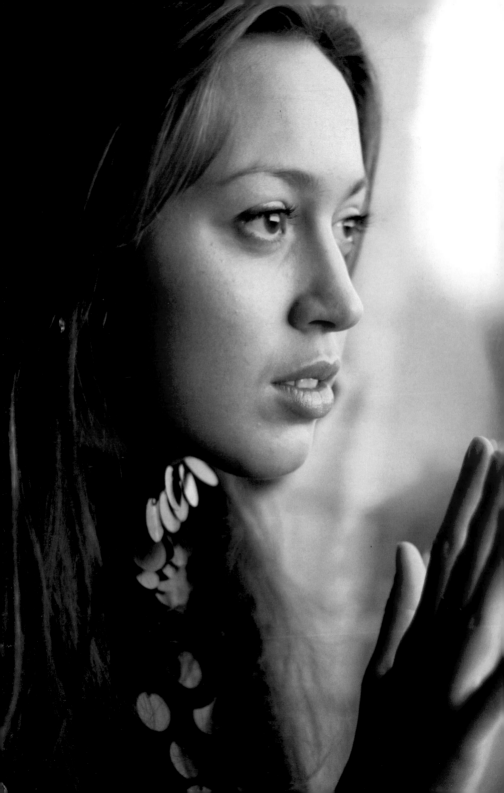

NATURAL LIGHTING AND SUPPLEMENTARY FLASH

This chapter covers lighting conditions outside the controlled environment of the studio, including indoor, outdoor, ambient or artificial lighting. The main light source for portraits outside the studio is the sun, but how this appears and how it can be used effectively depends on the time of day and the weather conditions. Questions such as 'what is the best time of day or the best weather conditions for shooting portraits?' will be answered. The role of fill-flash is also explored, along with using flashguns for supplementary lighting, bouncing light, long exposures and the role of diffusion and reflection in controlling light. The chapter focuses on how to make natural light work for you, either on its own or with a little help.

Natural light is at its best when coming through windows, counteracting the dark shadows inside.

What time of day is best for portraits?

Two times of day are good for shooting portraits, with or without flash: before sunrise and after sunset. The sky is bright enough and usually has plenty of colour, but the sun's light is also more muted, which allows the subject to look towards the light. Subjects can also stand against the sky, with the colours serving as a backdrop and allowing for the use of flash if necessary.

Bright, sunny conditions at midday are as bad as it gets for portrait photography, producing deep shadows and squinting subjects - unless they are wearing a hat to help keep the light at bay.

Early morning or sunset is a good time for portraits as the light tends to be warm and golden, especially in the summer.

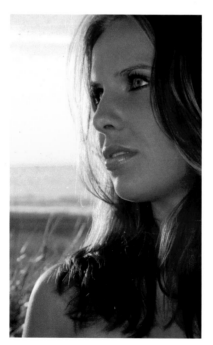

What's wrong with direct sunlight?

The sunnier it is, the brighter the light and the more the subject will squint. Turn the subject away from the light and they are then backlit and require flash or metering, which will lose the sky. Also, if the sun is high overhead, deep shadows will form around the eyes, making the subject look like a panda. The best solution is to get the subject to stand under copious shade, where the bright blue sky can be used as a backdrop.

Tip

Remember, the flashgun doesn't have an aperture. The f-stop rating in this case refers to how much light it generates – a lower f-stop number doesn't mean more light, it means the flashgun is generating less.

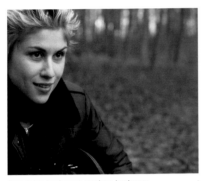

Complete cloud cover can be a landscape photographer's worst nightmare, but for the portrait photographer it ensures even light with little shadow – ideal conditions for portraiture.

With their back to the sunset, the subject would usually be dramatically underexposed. Either a reflector or a flash could be used to balance out the exposure.

What weather conditions are most flattering?

Just as a softbox spreads light from an electronic flash and makes it softer, so cloud cover does the same for sunlight. Unlike the landscape photographer, who generally dreads the descent of clouds, the portrait photographer is grateful for outside cloud cover as it diffuses the light and makes the subject less likely to squint. There is often still some shadow definition depending on where the sun actually is behind the clouds, but it is very soft. Clear evenings, sunrises and sunsets can also provide spectacular backdrops.

How do I avoid harsh shadows?

As previously mentioned, dark shadows on the face result when the sun is directly overhead. This is where fill-flash comes in handy. If the background has been metered, and the camera set to f/11 at 1/60 sec, then the flashgun should be set to f/8, which gives a flash ratio of 1:2 to the ambient lighting. This will help fill in the shadows under the eyes.

The shutter speed isn't fast enough for a wide aperture when using flash. What can I do?

Many flashguns have a limit on the speed with which they can synchronise with the camera. Generally, the faster the synchronisation speed, the more expensive the flashgun. With the shutter speed therefore limited to perhaps 1/60 sec, an aperture of f/22 may be required on a bright day. This is not a good aperture to use for most portraits as it produces a deep depth of field, which will include all the distracting background. The solution is to use a neutral-density filter to limit the light coming into the camera, so that a wider aperture can be used.

See also

Built-in flash and flashguns (page 30)

See also

Filters (page 56)

What are the problems with lighting portraits indoors?

By this, we are referring to location shooting rather than the studio where the lighting is controlled. The problems are threefold. Firstly, the light level itself can be severely reduced, so that even with a wide aperture, there is the risk of camera shake because the shutter speed is not fast enough. The second problem concerns the quality of light. If there is a large window letting in a great volume of light, then there is no problem. However, if the window is small and the main lighting comes from the house lights, colour casts can occur and could likely affect image quality. Finally, the third problem is one of space, particularly with digital cameras, which extends the focal length. If the room is on the small side, the photographer will be close to the subject and in order to get everything into the viewfinder, a very wide angle will have to be used, which leads to distortion.

How do I solve these problems?

There are three possible solutions to counteract low light levels. The first is to use fill- or bounce flash to increase the light level. Second, you can increase the ISO rating, either digitally or by using a higher rated film, so that the camera can use a faster shutter speed. Last, a tripod can be used to ensure that the camera remains immovable, although the subject should then also endeavour to remain as still as possible.

With low light levels (right), a tripod is handy, but not always practical, in which case higher ISO ratings are required.

A combination of interior tungsten lighting and generally low light levels can lead to creative photography, as seen here where the subject is blurred and the scene is a riot of colour.

Why is window light useful for portraits?

Sunlight beaming directly through a window is not conducive to portrait photography as it will produce harsh shadows and cause the subject to squint. However, it becomes effective if the sun is high overhead so the light coming through the window is diffused. If a subject stands close to the window, the light becomes flattering and it moves into shadow on the far side of the subject. If the windows have nets, the light will be diffused even further.

See also

Wide-angle lenses (page 24)
Bouncing flash (page 68)
Reflections and diffusion (page 74)

Window light, if filtered by curtains or nets, is a great light source. It is soft, flattering and allows the subject to look through the light. However, the same is not true for afternoon sunshine pouring through a large window, which will be harsh and create deep shadows.

What is bounced flash and why would I use it?

Bounced flash is created when you point a flashgun at a ceiling or a wall, bouncing the light off that surface and on to the subject. The reasons for using it are twofold. Firstly, direct flash can cause distracting and ugly shadows to appear behind the subject if they are too close to the background. Secondly, by bouncing the flash the light becomes much softer and more diffused, making the lighting on the subject more flattering. Bear in mind that the flash is the primary light source in these examples.

How do I bounce flash?

Simply point the flashgun up at an angle towards the ceiling or against a wall and follow the angles so that the reflected light will fall on the subject. Bouncing the light off the ceiling can be very effective and gives a more dramatic effect than firing the flash directly at the subject.

A flashgun that connects to the camera is much more flexible and powerful than built-in flash. The head can be tilted up to bounce the light.

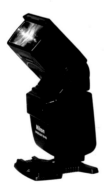

See also

Metering challenging lighting (page 49)
Reflections and diffusion (page 74)

What power settings do I use?

If the flashgun works automatically in conjunction with the aperture setting on the camera, then it will put out more light than if fired directly at the subject because it is reading how much light is being reflected off the subject. Fire away and check the results.

If, however, the flashgun is manual and used on full power, you need to work out what aperture to set on the camera and there are some calculations involved.

You need to measure the distance from the gun to the subject via the ceiling. You also need to know the guide number of the flashgun. Use the following formula:

Camera aperture setting = Guide Number (GN) / Distance to subject

However, don't forget that we are now bouncing the light and scattering it. As well, the ceiling can, depending on the material and reflectivity, also absorb light. Open the lens up by an extra stop, so that if the calculations give a result of f/8 on the camera, use f/5.6 instead.

Will the colour of the surface affect the flash?

Yes, it will. Although white surfaces reflect more light than black ones, the real issue here is if the ceiling or wall is coloured. The stronger the colour, the more of that colour will be present in the light bouncing on to the subject. Surround the subject with red walls and you'll get a reddish tinge to the light bouncing on to them.

When bouncing light off surfaces, the light comes from a different direction to where the camera is facing. This then eliminates the chance of red-eye, and the flash effect is diffused and looks far more natural.

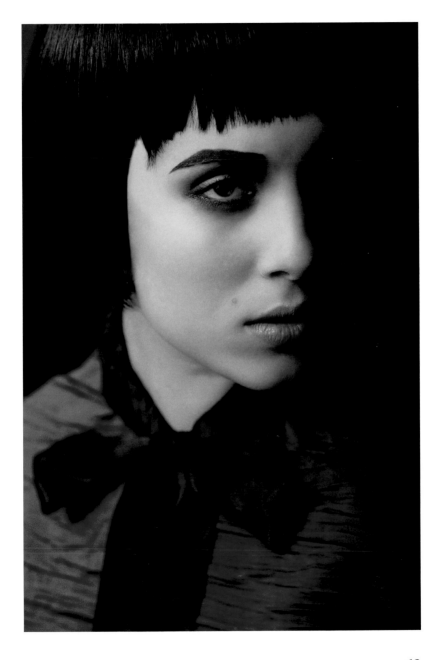

What does combining light sources mean and why would I want to do it in portraiture?

This means combining and recording the effects of different types of lighting, such as a sunset with flash, or tungsten lamps with flash. Different lighting types have different characteristics and colour, so various combinations can create a more creative portrait. While flash is similar to standard daylight – cool and white – tungsten can be used to add a warm glow.

How do I combine tungsten and flash?

Firstly, set the lighting up with your tungsten lamp and flash head to get the lighting effect you want. One example would be to have the tungsten lamp light the subject, while the flash covers half the subject and most of the background. Meter the tungsten output. Let's use f/5.6 at 1/125 sec for this example. With the camera to flash sync speed set at 1/125 sec as well, the flash should then be set at around f/4.6. What you are aiming for is the tungsten to be approximately a half to two-thirds of a stop brighter than the flash. Digital cameras should set their white balance to daylight/flash, so the colour from the tungsten can be recorded.

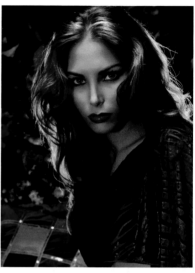

A tungsten lamp is used to add highlights to the subject's hair from behind and above. A small flash source to the left of the camera lights the face.

What effect does the combining of light sources have on colour?

As we've just discussed, with daylight film and a daylight AWB setting, tungsten will add a warm glow. If tungsten film is used, or the AWB set lower, then the warm glow will be rendered more white, while the background will be coloured with light tending towards blue.

Tip

Coloured cloth placed over a flashgun will lend the image that colour. However, the light that reaches the subject will be reduced depending on how translucent the material is.

See also

Colour temperature (page 54)
Filters (page 56)
Lighting outdoors (page 64)

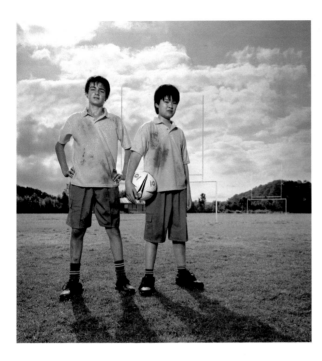

The only way to get a picture in a massively backlit scene is to use flash to even up the exposure so that the foreground is a similar brightness to the background. The exposure is weighted for the use of flash on the subjects.

How do I create a flash and ambient light exposure after sunset?

Having the subject stand with their back to where the sun went down will make them dark and shadowy in the photograph. The trick is to meter the background light first. Let us use the example f/5.6 at 1/30 sec. The camera with a flashgun should then be set in second curtain or rear synch mode, at the same settings. The shutter opens and records the background light correctly, then fires the flash at the end, which provides the light for the subject.

If you are using a flashgun that has to synchronise with the camera at 1/60 sec, then as the shutter speed has increased by one stop, the aperture number must decrease by one stop (which of course makes it wider) to f/4. Set the camera and the flashgun to these settings. If the

flashgun is completely manual, then you need to work out the distance to shoot the subject according to the usual flashgun formula:

Distance from camera to subject (feet) = Guide number of flashgun / Camera lens aperture

If, for example, the GN of the flashgun used in our sunset example was 56 and the aperture was set at f/4, then the distance to stand from the subject would be 14 feet (4.246m).

What effect do long exposures have on portraits?

Without any other input, a long exposure – taken either at dusk/night or in low light conditions, could result in camera shake, blur or a ghostly figure. The first two are largely undesirable, but the third could result in a creative image. Setting the camera on a tripod to record the scenery in sharp detail and letting the subject move about can result in a perfect shot of the location, but with the subject appearing as a ghostly apparition. The longer the shutter speed, the more pronounced the effect. A shutter speed of 1/4 sec will result in minor blurring, whereas one or two seconds will be significantly blurred. An exposure of four seconds or more will produce the apparition effect, unless of course, the subject is standing still.

With reduced light comes a slower shutter speed. Even if the camera is mounted on a tripod, any movement from the subject will make them disappear into a blur.

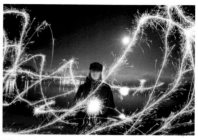

This is a long-exposure shot where the subject stood still and the photographer ran around with the sparkler. Because of the movement and the long exposure, the photographer is invisible, but the light trails and the subject are captured.

How do I create trails of light?

To add drama to your surreal or ghostly portraits, have the subject carry a light source. If it is small and bright, the effect will be a sharp light trail. If it is diffused and shaded – such as a table lamp – it will add light to the subject, making the apparition brighter. The camera should be mounted on a tripod, otherwise the scenery will be blurred as well.

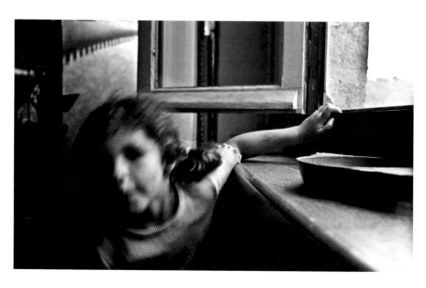

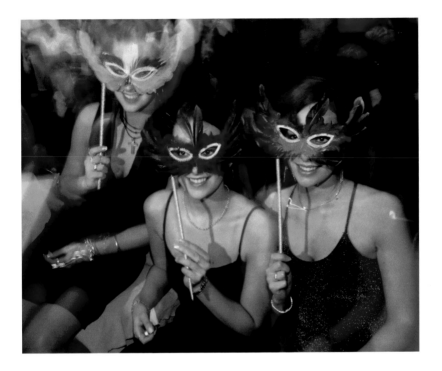

How do I freeze a person in motion?

You need to use a second curtain or rear synch flash mode with a long exposure. The shutter speed needs to be at least four seconds to allow the subject to move, then the flash will fire at the end of it, freezing them into place. This technique is most useful at parties or nightclubs where you want to record the background light, which is often highlight coloured. A direct flash would be so bright and short that the background would be rendered very dark. With the long exposure and second curtain shot, the ambient light is recorded, there are trails for where the people have been, and the flash freezes the action in place.

Long exposures tied into a burst of flash will combine both the colour of the ambient light and also freeze the subjects with the light of the flash.

Tip

If the flash is fired at the start of a long exposure, the ambient light trails appear in front of the frozen image, whereas if the flash fires at the end of the exposure, the trails appear behind the subject.

Why would I want to use reflections in portraits?

The use of reflections can be very effective. The reflection isn't viewed as the subject, it's a mirror image of the subject – a doppelganger or alternative version. This can be used to great creative effect.

How can I use reflections in portraits?

There are numerous ways to incorporate reflections, often centring on the reflectivity of the material being used to generate the reflection itself. A face pressed against a mirror, for example, can reflect one half of the face so that the image consists of the same two halves of the subject's face. As faces aren't exactly symmetrical, this can look startling or unusual. By excluding the subject's face from the main image and showing it in the reflection only, you are effectively inviting the viewer to see what is in the main image, hidden from direct view. The more diffused or distorted the reflection, the less it is associated with the actual physique of the person it is from, and the more associated it is with the psyche. From a practical perspective, unless the reflection is the focal element of the photograph, then metering for the main subject is the priority.

What materials are best for reflecting light?

Mirrors are obviously the best reflective items, but polished work surfaces can be very effective, too. Glass is reflective as well, but the angles need to be correct and a polariser will help reinforce the reflection here. Water is, of course, a classic reflective medium – the stillness of its surface dictates whether the reflection is almost identical to the subject, broken or distorted.

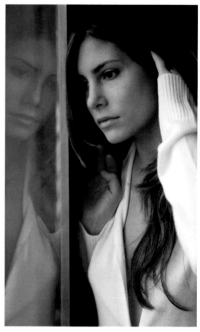

Reflections are a great device to use in portraits, especially when the subject is looking thoughtful or pensive. The metering should be taken for the subject rather than the reflection.

Aren't we meant to be avoiding harsh shadows?

Harsh shadows on the face or on the body can look ugly, while a shadow right behind the subject simply smacks of poor lighting technique. However, creating a shadow that offers drama, menace or is, in fact, the focus of the image – excluding the subject entirely – can be very effective as it represents the dark side of the subject. It works along similar lines to reflections, but here, it's a silhouette or dark presence and should be used as such. It can also be used for comic or dramatic effect in late evening sunshine so that the shadows are exaggerated and elongated.

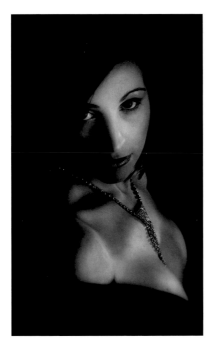

Natural devices such as tree cover, window frames or ornate woodwork can be used to cast shadows on the subject. The effect can also be created by using attachments on electronic flash heads. Either way, a dapple of shadow across the subject adds interest and intrigue.

What about using diffusion creatively?

As previously mentioned, diffusing light softens it, allowing for a flattering result. However, it can also be used more creatively. Diffusing light through a background allows the subject to stand against a spread of light. It can also be used to light backgrounds, but being so diffused, the light is spread very evenly at a lower level, with no shadows. Here, metering should focus on the subject first and foremost, to ensure that they are rendered correctly. The background lighting can then be arranged to be brighter or softer as the picture's intention dictates.

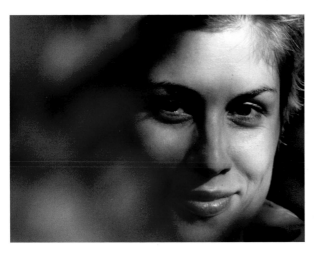

When using a wide aperture, the background will be out of focus. However, by placing the subject behind objects, the foreground goes out of focus, so the image is filtered and modified by the out-of-focus element.

See also

*Filters
(page 56)*

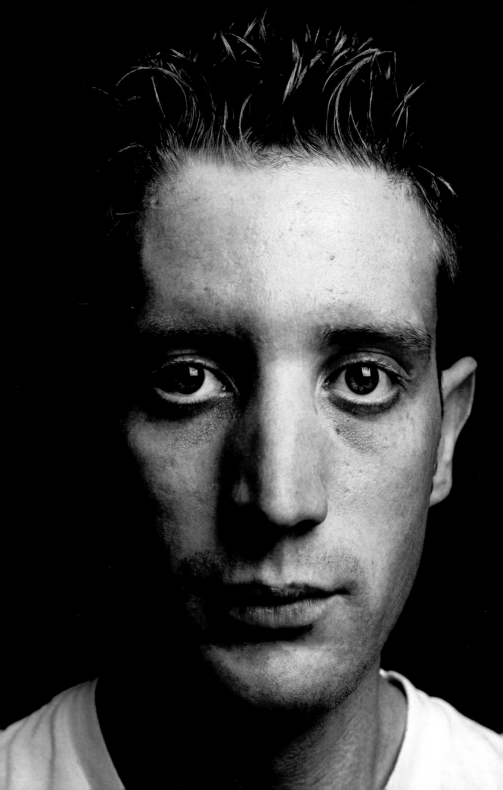

STUDIO LIGHTING

Unlike the great outdoors, the studio environment is where portrait photographers have almost complete control over the lighting available, allowing them to exercise their creativity. In fact, if only plain backgrounds and few props are available, then the photographer in the studio will need to be creative in order to produce something out of the ordinary. While the average enthusiast cannot afford a fully fitted-out studio, there are plenty of options for the amateur: beginner's kits of electronic flash units and softboxes are available on the market; camera clubs often rent studio time; and even renting a studio or location for a couple of hours is entirely affordable. What you do with the equipment is what this chapter is about – ranging from lifestyle portraits, to simple lighting set-ups, standard portraits, Hollywood-style images, to more complex and creative arrangements.

In the studio, you control the light and create the image you want to see.

How do I create a traditional studio portrait?

There are numerous ways of lighting studio portraits, and in fact, that's half the fun. However, the most typical arrangement is to have one light to the right side of the camera at 45 degrees to the subject, above head height, pointing downwards and another on the left, at 45 degrees, with the same positioning. If the lights are both set to the same power and are of the same model and make, then they should be very similar and the overall lighting effect will be balanced. If one light is set to be one f-stop more power than the other, and the scene is metered for that light, then there will be some shadow detail on the opposite side of the face and features. If you are an absolute beginner, it is a good idea to start with a very balanced lighting set-up so that you can concentrate on composition and directing the subject.

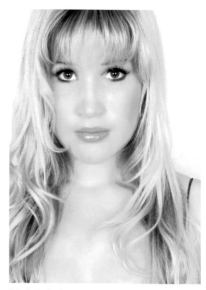

A typical, standard, studio portrait set-up ensuring even light on both sides of the subject.

To shoot an image like this, simply place two flash heads with a softbox each at either side of a centrally positioned camera. The flash units should point in at 45 degrees to the subject standing against a plain background. Both flash units should be set to the same power. Meter the sides and centre of the face (where it should be brightest), and then set the camera to that aperture reading, with the shutter speed set at the flash sync speed of 1/125 sec or 1/250 sec.

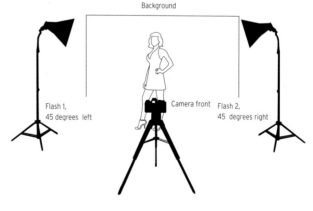

Background

Flash 1,
45 degrees left

Camera front

Flash 2,
45 degrees right

What is a flash meter?

The metering system in your camera is a reflected light system, so it measures the light bouncing back off the subject. This can measure the ambient or reflected lighting. Electronic flash, however, is synchronised to fire with the camera, so when the camera does its metering when the fire button is half pressed, there is only the ambient light to meter. To determine the exposure settings for your camera, which need to be set to manual for studio work, the power of the lighting should be metered by a hand-held incident light meter before the picture is taken. This records the light falling on to the meter's recording element, whether it is ambient lighting, or whether it is synchronised with the flash and records the flash exposure.

This inexpensive light meter connects to studio flash by way of a sync cable. More expensive models feature infrared connection which does away with the need for trailing wires.

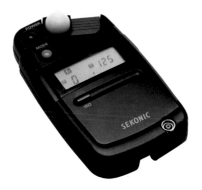

How do I meter electronic flash studio lighting?

You need the flash meter, of course, and this needs to be connected to the flash lights. There are a few ways of doing this. The most basic method is by using a sync cord that runs from the flash meter to the main key light. You can also get Wi-Fi and infrared flash meters that will trigger the lights; these do not require cables.

With the flash meter set to the correct mode of operation, you need to set the shutter speed that the camera is going to use. Usually this is 1/125 sec or 1/250 sec as these are the speeds at which electronic flash is designed to synchronise with cameras. In the studio environment, this usually means that the shutter speed and aperture combination is too fast/small to record much, if any, of the ambient light present.

The flash meter is held up at the subject and pointed towards each light that is being used in turn. A press of the fire button on the flash meter will trigger the light it is connected to, and this will in turn trigger any other studio lights that are being used as they have a 'slave cell receptor'. The slave cell recognises other lights firing and instantly fires its own light. The flash meter will then present you with an aperture value. This is the reading for the main light. You can repeat the process for all the other lights being used, even if the key light is triggered first. This will present you with a set of readings showing the strength of the light at various places in the set-up.

What is the key light?

Usually, this is the light that provides the main source of illumination. It is the one that provides the main reading, which is then used on the camera.

What are fill lights?

These are lights that provide extra illumination, but usually at a lower power than the key light. They are there to fill in shadows and provide a more rounded lighting effect.

What do I set the camera to?

Your camera must be used in manual mode only, with the shutter speed set to the light-sync speed discussed earlier, usually 1/125 sec or 1/250 sec. The aperture value is the result from the key light when doing flash meter readings. It is important to use the meter and not just set the camera aperture to the same aperture power setting of the key light because the other lights used will contribute and add to the overall lighting effect; it is this reading that you need for your key light reading and camera setting.

What are catchlights?

These are the lights used to illuminate the subject and the ones reflected in the eyes of the subject. One catchlight can add sparkle to an image - two large, square, softbox catchlights on either side of the pupil shows that an image was shot with formulaic lighting.

How do I meter tungsten studio lighting?

The good news here is that you don't need a flash meter because the metering systems in your camera can do the trick. With tungsten being a continuous light source, you can arrange the lights and fill the shadows as you see fit, then meter accordingly by using your camera.

Tip

To get more power out of your budget lights, move them closer to the subject or try using them with less diffusion. For example, softboxes often have an inner diffuser as well as an outer one. Removing the inner diffuser will let more light through.

Tip

More expensive electronic flash will give greater power, which results in faster recycling times and a greater aperture range.

Why is using only one light more creative than a standard two-light set-up?

In the previous topic, it was explained that if you set up two equally powered lights on either side of the camera, then once the metering was done, you could concentrate on posing and composition. By removing one of the lights, you create light and shadow and change how the image looks completely. With just one light, you have to consider the creative effect of light positioning. Once you've shot your fill of standard two-light shots, take one away and start experimenting.

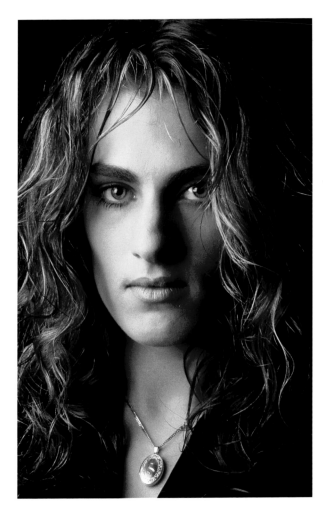

This image shows that one light can be far more atmospheric and stylish than using two with a routine lighting arrangement. The further around the side the light is moved, the darker the shadows on the opposite side of the face.

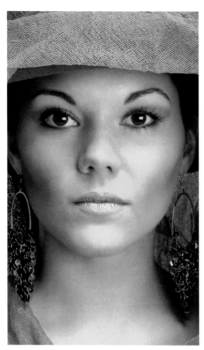

This image shows one main key light to the right, but with the shadows on the left side of the image being brightened by use of a reflector or other fill-in device.

Tip

A large, white reflector – even if it's just a piece of card – will bounce enough light back when using one light, and acts as a fill light on the other side of the subject's face.

What kind of different looks can I get with one light?

Surprisingly, quite a lot. As discussed in the last question, the further around the light goes from the front, the more severe the shadows. Placing the light underneath the subject's face and pointing it upwards gives a chilling, film-noir effect. On the other hand, placing the light above the face and pointing it down gives a more modern, fashion-style look. The diffusion of the studio light also plays a part here. A giant softbox or octobox will give a huge spread of soft light, while a smaller one will have a sharper fall-off. A brolly used to bounce the light back will be a little harsher with more defined shadows, whereas using an electronic flash light with no diffusion at all will produce the harshest light of all, the positioning of which can be used to replicate the classic era of Hollywood portraiture in the 1930s and 40s.

Are there any problems with using just one light?

Unless the single light is pointing directly at the face, there will be shadows on it. The farther away the light is positioned from the front of the subject, the darker and more shadowy the opposite side will get. Sometimes you might want this dramatic effect, other times you just want some highlight definition and a slightly darker side, but not one that's harsh and impenetrable. To reduce the shadows, you need a reflector to bounce some light back in, or in fact, another light altogether.

What is classic Hollywood lighting?

This generally refers to the golden era of Hollywood portraiture where stars such as Veronica Lake, Clark Gable and Vivien Leigh were signed to contracts by individual film studios. As such, the studios arranged for publicity portrait photographs, either on-set, backstage or in carefully arranged spaces within the set environment.

The lighting used was tungsten powered and although the lights were generally very large and ran very hot, the exposure time would be long – anything from 1/4 sec to a couple of seconds – so the subject had to stay quite still. The golden era took place around the 1930s and 40s. Towards the end of the latter decade, faster film, cameras, and lenses were introduced, allowing the actors and actresses more freedom of movement.

Cameras of the time were generally very large and unwieldy. They used extremely large plate negatives and before the prints were made, an army of retouchers would scrub out blemishes and pencil in detail where needed. If you thought retouching was a modern, digital phenomenon, think again. It was being done 75 years ago.

As the lighting was continuous and usually undiffused, it made it easier to arrange with regards to shadows and highlights. While many arrangements were quite simple, there were others that used a complex battery of lights to create the desired effects. There are two key signature lighting effects that have currently been recycled and put back into current use: loop lighting and butterfly lighting.

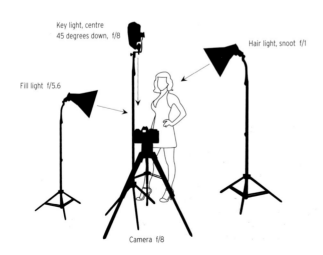

Key light, centre
45 degrees down, f/8

Hair light, snoot f/1

Fill light f/5.6

Camera f/8

This illustration shows the set-up for butterfly lighting, the signature effect of the 1940s. It's obtained by having the key light above the camera pointing down, so that a double-wing shadow appears under the nose.

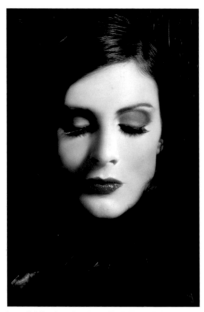

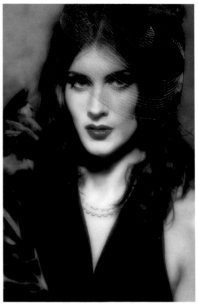

Loop lighting is a signature effect of the 1930s where the shadow from the nose reaches across the face diagonally. If you want to be a purist, ensure it doesn't touch the lips or reach the other shadows.

This is the 1940s set-up in practice with the key shadow appearing under the nose. The other lights add fill from the side and highlights for the hair.

How do I create loop lighting?

Loop lighting is the signature lighting effect from the 1930s. It is produced by having the key light to the side of and above the camera, pointing down. With no diffusion, the idea is to cast a shadow from the nose that extends diagonally down across the face, without it reaching the lips. As you can imagine, this is easy to do when using tungsten lighting, but less so when using flash. If you have a modelling light on your flash, turn it on to see where the shadows fall. Otherwise, a little trial and error will be necessary to get the shadows in exactly the right place.

How do I create butterfly lighting?

This is the signature lighting effect from the 1940s and is the one that has been revitalised for weekend fashion supplements and perfume adverts. Here, the key light is dead centre above the subject and pointing downwards (see previous page) so that the shadow of the nose appears directly underneath in a butterfly silhouette. Again, the shadow should not extend to reach the lips, and using a model light with flash will make it considerably easier to set up.

Does this mean there is just one light in Hollywood lighting?

On the contrary, there could be numerous lights. What we've just discussed relates to the key light, which is the main one creating the shadow on the face, and it is this light that you should meter for. Extra lights can be employed to introduce highlights and lighten the background. One or more hair lights were almost always used, whether from above or as back lighting. The hair lights would be set at one or two stops brighter than the key light.

What is film-noir lighting?

Film noir largely spanned the period from the 1940s to the early 50s, but its influence was still evident in black-and-white movie lighting during the 60s. The moody and dramatic lighting schemes were well suited to the thriller and crime genres, with morally ambivalent characters and double-crossers aplenty. Although the stark and dark lighting was inspired by French existential cinema of the 1930s, it perfectly suited the low budget B-movies that comprised a fair amount of film noir in Hollywood during the 40s. The lighting helped to disguise the cheap sets and recycled props on the movie studio lot. The bigger-budget films had better sets, bigger named actors and more location filming, but still used the expressionist lighting and disorienting visual schemes. If you have the time, have a look at The Big Sleep, The Maltese Falcon, The Killers and Double Indemnity.

How do I get the film-noir look?

While a low-key approach is obviously prevalent here, the aim of film-noir lighting is not to make the subjects look glamorous, but to create a dark and dramatic atmosphere. One method of doing this is to have the key light below head level so that the cheeks tend to shadow the eyes. This is not a flattering look, but it is a dramatic one. As with the signature lighting themes of classic Hollywood, it's important to use stark lighting with no diffusion so that the shadows are deep and well-defined. Using multiple light sources helps, as they can then cast more shadows and illuminate disparate elements of the set-up.

See also

Simple lighting arrangements (page 81)

Tip

Study portraits from the golden era of Hollywood and try to work out the position of the key light and other light sources from the shadows, strength of lighting and particularly the catchlights in the eyes. Try to recreate a classic portrait shot before trying out your own styles.

What are lifestyle portraits?

This generic description doesn't really refer to shooting people enjoying their particular lifestyle – it's a general reference to a style of portraiture made popular by certain high-street photographers and embraced by the wedding photography market. The lifestyle portrait more often than not uses a pure white background and flooring and has subjects, usually families, laughing, smiling and enjoying themselves.

In the wedding market, the terms 'lifestyle' and 'informal' also apply. Here, the same ethos is taken out of the studio and applied to the event so that the subjects are moving about, enjoying the day. It's similar to candid photography and the wedding photographer will include candid shots in the final portfolio. However, it is slightly staged in that the subjects are aware of the camera's presence.

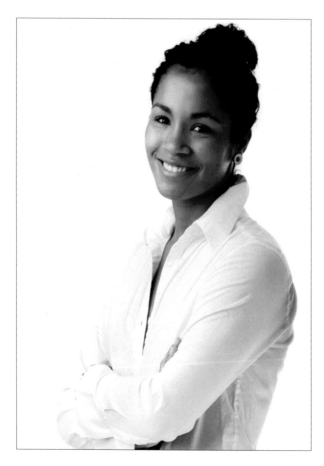

This picture ticks all the boxes for lifestyle photography: pure, white background; a happy, smiley face and a natural pose.

How do I light lifestyle portraits in the studio?

The lighting is usually quite simple and consists of a couple of key lights on either side of the shooting area. It has a balanced output from both light sources so that the subjects can move around freely without the need for constant metering. This set-up is also popular with high-street photographers – with the lights metered and in position, images can quickly be shot and processed without having to change the arrangement.

Tip

If you find you are having trouble focusing while your subjects move around, fix the focus at the point where most of them are and ensure that you are using a narrow aperture for greater depth of field. Alternatively, simply switch to manual focus and adjust as fast as you can.

What directions do I need to give to the subjects?

This depends on who you are shooting. If it's a single person and they are young, then it's a popular pose to have them lie on the floor. Groups of children or a couple of teenagers also work well lying down; if there are more than two, sitting them on the floor together will work. In all cases, they should be laughing and smiling. The idea is to get them to relax and for the photographer to shoot away. You should not be saying, 'Smile at the camera, now hold it...' Instead, shoot rapidly and get them to interact. Music is often a great icebreaker, so put on something your subjects will relate to. Older couples may be more at ease standing up – they need to be relaxed and smiling for the camera. As before, shoot a sequence of shots and use props if necessary.

To set up this kind of shot, you need lights set brighter than the key light and aimed at the background so that it is rendered as pure white. Set a light on either side of the camera to fully illuminate the scene and let the subject move around in the centre.

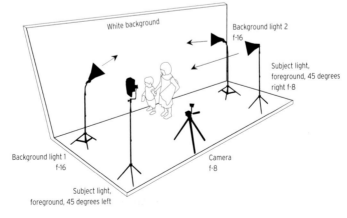

White background

Background light 2
f-16

Subject light, foreground, 45 degrees right f-8

Background light 1
f-16

Camera
f-8

Subject light, foreground, 45 degrees left

87

How do I set up a shot using a hairlight?

If you want to get highlights in the hair using a hairlight, the light itself should either be small, or the attachment to it should be small. Otherwise, there will be a large amount of unfocused light that goes everywhere. You can use a small softbox for a hairlight, or a small dish reflector, but this is what the snoot attachment is for. A tight cone of light is provided, which can be accurately targeted on to the hair. The key light and all the other lights should be set up and the subject positioned in the right place. If you are using a snoot, the subject will need to be positioned and still. If a small softbox is being used to fire across the hair rather than from further above, then some movement can be tolerated.

Meter the key light and then set the hairlight to be one or two stops brighter in terms of power. Use your hand-held meter to take readings from the hair where the light is hitting it to check the power level. If shooting on medium-format film, it's worth using a Polaroid backup for any complex flash set-ups in order to see exactly where the shadows are. Obviously, a modelling light on the flash, even though it's being directed through a snoot, is invaluable for precise placement. Digital users should shoot a couple of test pictures and check that the highlights are in the right place on the hair.

Tip

Remember, two lights aimed at the same background will produce a higher light reading than the power setting on each one.

How do I light the background separately?

The way to approach this is to set up the key lights for the subject first, get all the meter and camera readings done, then arrange the lights out of view, aiming at the background. If you want the background to be dimmer than the subject, then set the power of the light(s) to be one stop lower. If you want it to be brighter, then set it to be one stop higher. For a straightforward portrait, you don't specifically need to light the background. However, if you are arranging a complex studio set-up with a lot of props, then the background would need to be lit.

How do I get a pure white background?

Even a white background can have imperfections. To ensure that your background is whiter than white, it needs to be overexposed. Use two lights, one on either side of the scene, pointing at the background, and set them on maximum power. Ensure that your key light uses a lot less power so that the flash ratio between foreground and background exceeds the capability of the camera/film to record the background. That way the background is rendered as pure white.

Note that the inverse square law of light intensity still applies here: as you double the distance from the flash, the light level is halved compared to what it was originally. You can use this in reverse by placing the background flash units closer, but out of shot so that they apply more light to it. If you aim to meter and shoot the foreground subject at f/8, but the background is metered at f/22 or f/32, then there is three or four stops difference between the two, which should ensure the background is completely white – print film will require the greater difference as it has the wider tonal range.

How do I get a halo around the subject?

The halo is produced by having a light behind the subject set to a higher power than the key light used to light the subject. The camera is obviously set to the key light. As an example, set the key light for the subject at f/8, and position it to the right of the camera. Use a fill-flash light on the left at f/5.6. Use either a snoot to aim across the back of the hair or another large light to illuminate more of the back and head. If you want an even halo, then the light has to be directly behind the subject, otherwise it can be off to the side. If you want more hair on top to be in the halo, then the rear light should be above head height, pointing down. The camera

might need support from a boom arm in order to do this. You do not want the flash head itself to be in the shot as this will cause flare and a huge highlight that will ruin the image. Wherever the light source is, it should be out of the line of sight of the camera. Set the power on the halo flash so that it is more powerful than the key light. Go around the back of the subject, use the flash meter and point it at the halo-generating flash, to take a reading. Adjust the power of the light so that you get a reading of f/11 for a halo effect. Set it higher, say f/16, for a more dramatic effect. However, be careful and watch out for lens flare.

By using a brighter light to the side and rear, a pleasing halo effect through the edges of the hair is possible. Be careful not to let the camera lens see the light as flare or image degradation will occur.

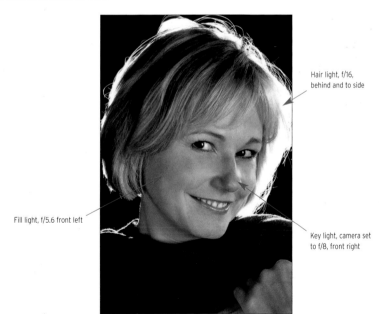

Hair light, f/16, behind and to side

Fill light, f/5.6 front left

Key light, camera set to f/8, front right

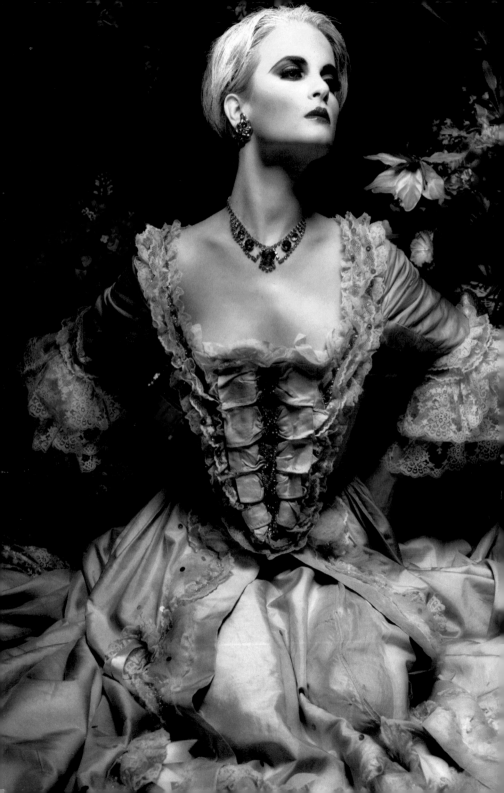

COMPOSITION AND POSING

Once the technical elements of lighting and capturing a portrait have been set up and nailed down, you are left with a consideration that is very specific to portraiture. In landscape photography, the elements can combine to create a pleasing vista, but the viewer won't notice if one tree has branches in slightly the wrong direction or is leaning the wrong way. In portraiture, the composition of the subject within the scene and how they carry and arrange themselves make all the difference between photographs that have impact and those that either look ordinary or fail altogether.

People are so conditioned to look at other people and they will notice the smallest flaw or element that doesn't seem right, even if they can't quite put their finger on what is wrong. In this chapter, the technical science of photography makes way for the artistic side of photography where we discuss everything from the impact of eye contact to the problem with hands, feet and empty space in a photograph. The styles and rules of composition change over the years, so discover what is important and figure out what rules you can bend and break.

Composing and posing the subject can make the difference between a good image and a great one.

What is depth of field?

Depth of field is the distance between the nearest and the furthest objects within the image. The photographer determines which objects are in sharp focus. The focus point sets where the sharpest focus is, and the lens type, focal length and aperture all dictate how much depth of field you get. Generally, one third of the depth of field appears in front of the point of focus and two thirds appear behind.

How does aperture selection affect depth of field?

The wider the aperture, the lower the f-stop number, and the more shallow the depth of field. In other words, there is less of it and more of the picture is out of focus. A high f-stop number, which indicates a small aperture, results in the most depth of field. This is why a prime lens with a widest aperture of f/1.8 or f/1.4 is so useful in portraiture.

How does lens focal length affect depth of field?

The longer the focal length, the less the depth of field, so a telephoto lens at 200mm would produce considerably less depth of field than a wide-angle lens at 24mm, using the same aperture.

What depth of field is best for portraits?

If you were to be given one tip and one tip only for portraits, it would be to get the background out of focus. A wide, open aperture throws the background out of focus, removes any distracting elements and allows the viewer to concentrate on the subject. However, there are times when you want the subject to appear at one with their background surroundings, a luxurious country mansion, for example, or to create a contrast where an expensively dressed subject poses amongst urban grime and decay. In such cases, seeing the background is important, so a setting of f/8 or higher would be appropriate.

Your focusing needs to be accurate as the depth of field reduces. At f/1.8 on a 50mm lens, there is only a small depth of field – if the focusing is off, important features will appear soft at best and out of focus at worst. When dealing with very shallow depth of field, it is considered good practice to focus on the eyes, specifically the eye nearest to the camera.

A wide, open aperture with a low f-stop number creates a shallow depth of field, which throws the background out of focus (left).

Use a narrower aperture (a higher f-stop number) if you want more of the background and foreground stay in focus (right).

What are common mistakes?

Keeping the background out of focus will help eliminate common mistakes, such as elements that appear to be attached to or run through the subject. Poles and light fittings coming out of the head are the obvious ones. If you are using flash and automatic mode in a picture, this tends to happen more as the camera will use a narrower aperture due to the brighter scene. Hence, auto-flash pictures tend to give the worst results. The other common mistake is the one detailed in the previous question – using a very shallow depth of field that can lead to the subject being out of focus. This is very problematic if the subject is moving as they are likely to move away from the initial point of focus.

A long lens, or telephoto lens, can be used to narrow the field of view to include just the subject, keeping out distracting detail. (Image by Brad Kim)

It's a small room with a lot of background clutter. What should I do?

As we've discussed, use a wide, open aperture but also stand as far back as possible. Also, move the subject forward and as far from the background as possible to separate these two elements.

Tip

Can't get the subject far enough away from the background to avoid including it? Use bounced flash off the ceiling as this will light the subject, but leave the background looking darker and less intrusive.

What is the rule of thirds?

While the rule of thirds is generally applied to landscape photographs, the basic form has some merit for portraits, too. The rule itself involves dividing the scene into thirds by using horizontal and vertical lines – some cameras even have this grid overlay as a display option. Place the major points of interest where the lines intersect. At a basic level, it also requires you to place the horizon on either the top or bottom horizontal line, and for portraits, to place the subject on the left or right vertical line.

What is wrong with placing the subject in the middle?

This composition can look staid and dull, with nothing going on to either side of the subject. However, you can get away with this if you create interest by using other tactics, such as dramatic lighting and close cropping. David Bailey, in his famous celebrity portraits of the 1960s, broke with convention to create a look that has been copied ever since. However, know the rules first in order to fully understand how to break them to creative effect.

In this shot, the subject's head is off to the right, towards, but not exactly on, the top right junction. Her hand on the air rifle sits on the bottom left junction. The key here is that the subject is primarily on the right and looking left into the picture, while the angled pose ensures she fills most of the bottom third of the picture as well.

What is dead space?

This is an area in the image where the eye doesn't look. You cannot fill every single centimetre of the screen, but the eye must be drawn through the image. This is why the central positioning of a subject in the mid-distance tends to kill a photograph – the areas on either side become dead space.

How do I lead the eye through the picture?

This can be done in two ways. It can be achieved two-dimensionally so that you are looking at everything in the foreground of the photograph and it leads the eye around the image. It can also be done three-dimensionally, either from the back to the front, or from the subject into the background. By placing the subject off-centre and facing into the rest of the image, you invite the eye to look across. Placing the subject to the left and having them look left instantly kills the space on the right and leads the viewer's eye directly out of the picture.

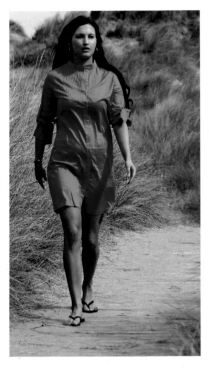

Tip

Shooting portraits for editorial stock photography? Always make sure that anything intended for front covers is in portrait orientation and has room at the top for the masthead, with space on the left for text copy.

The subject fills the left side vertical while the path runs across the bottom horizontal third off into the background.

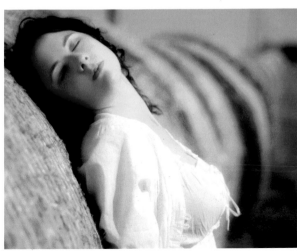

Here, the subject occupies the left side of the picture and is looking towards the camera, not across the picture. The composition works because the subject is leaning against a rolled stack of hay that then leads off into the distance and across to the right, filling out the space.

What are the different types of portrait lengths?

Quite simply, this is how much of the subject you include in the picture. This dictates how easy it is to create the photograph, and different lengths present different problems. Also, some lengths work well in portraits while there are those that can look odd (although all rules are there to be broken!). The three main portrait lengths are: head and shoulders, the three-quarter-length shot to just above the knee and the full-length shot.

A head-and-shoulders shot is the easiest type of portrait to shoot because all distracting elements could be easily removed from the picture.

A three-quarter-length shot is more interesting than a head-and-shoulders shot as you are seeing more of the subject. It is easier to achieve than a full-length shot because you don't have to worry about the subject's feet or their placement within the environment.

Which is the easiest to shoot?

Head-and-shoulder shots are easiest to shoot because you don't have to worry about hands, legs, body angles, arms, the background or how the subject is standing. Instead, you are freed up to concentrate on facial expression and lighting.

How do I make a head-and-shoulder shot look interesting?

It's possible to shoot the subject straight on to the camera, but if you fix this element, the expression needs to be direct and engaging; the lighting on the face should be more interesting than simply being evenly lit. Eye contact also becomes a key factor. This is the most engaging device you can use as it draws the viewer right in and makes a personal connection. If there is no eye contact, then the message is one of either mystery or disconnection, in which case the other elements – head angle and lighting – need to be more dramatic.

Head-and-shoulder shots may be easy to do, but it's more difficult to make them look interesting. Here, the camera focuses on the eyes surrounded by the veil to create an intriguing and luxurious image.

97

What's good about shooting three-quarter-length portraits?

With this length you have the advantage of including most of the subject's torso, so clothing, arm position and more background all come into play, making for a more interesting photograph (see image on page 96). As well, the feet are excluded, so it makes it easier for the subject to pose. The main elements to consider are the arms – ensure that they are not in exactly the same position by moving one arm slightly forward, the other slightly back, and it will look more natural.

What are the issues when shooting full-length portraits?

As all of the subject is now included in the shot, there are far more elements that need to be composed and considered. Specifically, you now need to incorporate the legs and feet into the picture. The subject can be photographed walking naturally, or if standing and posing, ensure that their legs are not on exactly the same plane facing the camera. If they are, turn the torso slightly and move the camera around so that one leg is slightly nearer the camera than the other. Ensure that feet are pointing in different directions and not towards each other.

See also

Posing the subject (page 99)

Getting someone to pose naturally for a full-length shot can be difficult and awkward. Instead, get your subject to move around naturally and take a number of shots in order to capture the winning shot.

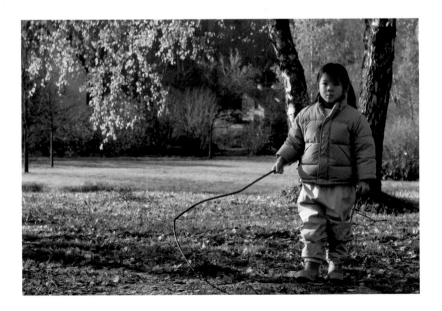

These two shots feature subjects that look thoughtful. One is making eye contact with the camera (right) and the other isn't (above). Both give different meanings, with the image above being far more enigmatic.

On the right, although the subject isn't smiling, the fact that she is making eye contact draws the viewer into the picture and invites discussion regarding what she may be thinking.

Does the subject need to make eye contact?

No, not necessarily. If this is the case, however, then you need to make the rest of the picture work harder. When the subject makes direct eye contact with the camera, they are in effect looking directly at the viewer in the final image, and this gives significant psychological impact.

What do I do with the hands?

Hands can be a real problem area when shooting portraits. For children and anyone wearing trousers, sticking one hand in a pocket is usually a solution. If you don't have anywhere to place the hands, ensure that they are not in the same position otherwise it will make the subject look uncomfortable. Keep an eye on hands during a portrait session and if the subject has difficulty figuring out where to place them, introduce some props to the shoot. If they have something to hold, they will pose more naturally with it.

Using a wide-angle lens in a confined area is another consideration. Wide-angle lenses create distortion, so if the hands are the nearest thing to the camera they will become elongated and you run the risk of either having 'clown hands' or the dreaded 'bunch-of-carrots' look. In this case, ensure that the hands are not nearer to the camera than any other body part – tuck everything in to the same vertical plane.

Finding something for the hands to do can be a challenge. Props and accessories will make them look more natural, or turn the concept around and make the hands and props the focus of the image, as in this picture of someone praying.

Turning the head can result in creases showing up on the subject's neck. For subjects with long hair, a sneaky way around this is to casually drape the hair around and down the neck to cover the creases up.

What's wrong with standing face on to the camera?

While you can make this work, you'll need to be clever with lighting, expression, styling and props. If the person simply stands in the middle of the picture, face on, with dull lighting and a cheesy grin, then all you are capturing is a holiday snapshot. If you are starting out in portraiture, it's advisable to avoid this kind of shot until you are confident about manipulating the other elements required to make the shot work.

How do I make the subject appear more dynamic?

If the person is standing still, simply move to one side and ask them to look at the camera. Instantly, the body position is angled and by looking at the camera, the subject will usually move their head around as well. You can push this to more extreme levels by having the subject look over their shoulder, but this can also go wrong. The aim is to make the subject look more natural so that the feet aren't planted next to each other, and that the body is slightly angled to the camera position.

If you are only going to include the head, shoulders and part of the torso, the composition can look very static. It is better to either angle the body or angle the camera so the subject fills the frame from top left to bottom right.

How can I avoid neck creases?

The more the subject turns their head, the more creases will appear in the neck. This is generally frowned upon, but if the subject is older or has more wrinkles anyway, then it doesn't matter. This is mainly something to consider when shooting female subjects or fashion images. Don't rotate the neck too far; drape long hair around and over the neck so that it breaks up any creases. Scarves are also good for counteracting this problem.

What's the problem with crossing legs?

This is a classic compositional problem. If the subject is sitting down and shot from the side and the legs are not straight, the leg farthest from the camera can appear cut off by the leg nearest the camera. Make sure that the foot of the leg on the far side of the camera doesn't look disembodied.

Few people look attractive being photographed from below head height, and this is considerably worse if they are carrying a few extra pounds. Shooting from above will eliminate any sign of the neck, and also helps those with a chin that may otherwise dominate the facial features.

Are bra straps to be avoided?

Until quite recently it was frowned upon to show bra straps in portraits, more from a puritanical perspective than a photographic one. However, you don't need to worry about showing bra straps because they are items of underwear. What you should be aware of is whether the bra straps make the photograph look messy or if they detract from the image. If you are aiming for a high-class image, perhaps whilst shooting the subject in an evening dress, then it is advisable to either cover the straps or ensure the subject is wearing a strapless bra.

Tip

Photographing someone who is overweight? Get them to lean in towards the camera, focus on the face, and use a wide aperture to throw everything else out of focus.

What's the best way to shoot someone who is overweight?

If someone has a double chin, they won't thank you for getting out the wide-angle lens and shooting from below. Instead, elevate the shooting position so that extra chins are diminished or entirely hidden by shooting from above chin level. Stand farther back and use a longer lens to avoid distortion and to narrow the field of view. Also, pay attention to clothing so that the subject wears items that are flattering.

How can I photograph babies or infants?

Babies are easy to photograph because they don't move around much once they are in a supported and padded environment. However, you will need to provide a point of focus. The best way of doing this is to get the mother to stand near the camera to get the baby's attention. This way, the baby will look towards the camera. For infants, include toys or having the mother hold toys so that the subject will look towards her.

What would be considered an unusual angle and why would you shoot it?

By its very definition, an unusual angle is a viewpoint that you don't normally see in portraiture. There could be specific reasons why a specific angle or viewpoint has been chosen. It could be to overcome physical limitations, to hide elements of clothing, or more likely, to make the image more dramatic, intriguing or eye-catching. One of the more common tricks with viewpoint is to combine it with a wide-angle lens that is used close-up so that it hugely exaggerates the nearest element and diminishes the rest.

Unless you are a member of a basketball team, the view from two feet above someone's head is likely to be an unusual perspective. Shooting the subject from this angle makes the image focus on the face and expression as pretty much everything else disappears out of shot.

What kind of wide-angle lens are we talking about?

All wide-angle lenses, that is, anything with a focal length of under 50mm, will cause distortion. However, if you really want to go to town with the effect then something in the range 18-28mm will have a profound effect. The most extreme example is, of course, the fish-eye lens, with approximately 8-12mm focal length.

What effect does shooting from floor level have?

If you take a wide-angle lens down to the floor and shoot upwards, it will elongate the subject's legs significantly. This may sound like a great idea if you are shooting someone with short legs, but it also means that you are looking up underneath the chin, and this rarely makes for a flattering shot. However, there's a variation worth pursuing. If the subject sits on the floor and points their legs towards the camera, the legs will be elongated, but with the camera at head height everything else will look fine.

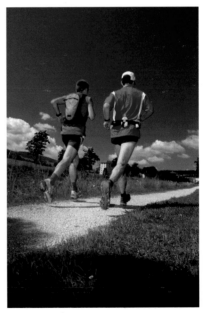

Shoot from low down with a wide-angle lens and the distortion tends to make legs look longer, which can be used for creative purposes. Here, the runners are striding away into the distance and the leg work is given more emphasis because of the low angle.

103

How do I arrange a group shot for a formal portrait?

If the people being photographed want a formal picture, start by getting the two most important people to stand in the middle. If there are a lot of people in the group, then it can be better to arrange two lines with the shortest people at the centre. The most likely situations for formal groups are large family gatherings and weddings. Weddings should be done according to the importance of the subjects – bride and groom should be at the centre with their families spreading out at either side, starting with best man and the bridesmaids. For the family shot, think in terms of triangles. Arrange people in groups of threes so that there are two people with roughly the same height on either side of someone taller, all within the confines of relative importance. Triangles break the lines up and avoid the dreaded slope where people on one side are taller than the other and it appears they are sloping off the picture.

At first glance, this seems an awkward composition, but note the lines and shapes of the subjects. They are in fact the same. The woman is standing and the man is looking directly at the camera in order to prevent the composition from looking rigid.

How can I make a group shot more dynamic?

Put depth into it, and by this, I don't just mean two lines of people. Elevate your shooting position so you can see all the faces and make 3D triangles that go back into the scenery. Or, have one person at the front and another behind. The other trick is to put people into a line leading back out of the picture. If they then step to either side or tilt themselves, you can have a lot of fun with a very simple arrangement.

How do I deal with awkward people?

With any large group there are those who are co-operative and helpful, and those who aren't. It's down to your social skills and patience to get them organised. If someone is being extremely awkward, then the best thing to do is to employ the help of the person paying for the shoot. Ask them to round up the people who aren't getting into position, and to ask the person to take their position or stand out of the photograph.

Someone else with a camera is copying my shots. What should I do?

This usually happens at weddings. All you have to do is bear in mind that you are being paid to shoot the pictures. Arrange things as you want, get set up, and if anyone infringes on the shot, politely ask them to move back as you are taking the picture.

You have to accept the fact that people are going to stand behind you and take snaps, but if they start directing subjects or asking them to look into their camera while you are doing it, you must intervene and ask them to wait until the paid-for shots are over. If you don't, it will continue all day.

The key to group arrangements is to consider the heads. Make lines or shapes with them. In this shot, the heads curve inwards to form a smiley shape.

Tip

If the occasion is for one person or a couple, and there is a crowd present, get the subject/s to stand in front of the main party and use a wide aperture such as f/2.8. The person or couple will then be in focus, while everyone else will appear out of focus in the background, emphasising the importance of roles.

37 |

What camera settings should I use at parties?

The problems with the party environment are the same regardless of whether you are a professional photographer recording the event, or a point and shoot attendee. For one thing, the light levels indoors are going to be low. If it's a children's party, it is likely to be brighter, in which case you might get away with a high ISO-rated film and a wide aperture – something like ISO 400 or ISO 800 at f/1.8 or f/2.8. If it's a party for adults, such as candlelit gatherings – then the light is likely to be very limited, in which case you're going to need flash.

Do I need to use flash?

It's highly recommended that you do. With numerous people or kids moving around and low light levels, it will be hard to get a focus lock while avoiding camera shake as well. There is usually a party mode on a point-and-shoot digital compact camera. If this option is not available, look for the second curtain or slow sync flash mode. This will combine an ambient light recording of all the neon and tungsten lights in the room, as well as add a flash of white light to capture the action. Note that the slower the shutter speed, the more blurry the ambient light recording will be. If using an SLR with a separate flashgun, the bounce flash method from the ceiling will provide plenty of light and avoid ugly shadows directly behind the subjects.

How do I avoid getting red-eye?

As previously discussed, the culprit for this effect is on-camera flash aimed directly at the subject. The best solution is to use a red-eye reduction mode that works by pre-firing spikes of light causing the iris to contract before the main flash goes off. If using a separate flashgun, bouncing the light off the ceiling will avoid this problem completely.

What kind of lens would be best for parties?

Due to possibly constricted spaces and the general tone of this type of photography, the quality of prime and portrait lenses can be sacrificed for a wide-angle zoom. To minimise distortion stand as far back from the subjects as possible, and ensure that everyone is roughly the same distance away from the camera. In terms of widest aperture available, the greater the zoom range, the less you have to play with in terms of maximum aperture. Narrower apertures mean less light and more problems with camera shake. If possible, use a short-range, wide-angle lens, such as a 17–35mm range.

Even with burning candles providing some illumination, this image still required an ISO rating higher than ISO 1000 in order to get a fast enough shutter speed for a picture with no effects from camera shake.

Tip

If shooting at a nightclub or adults' party, use the second curtain flash option, which combines the flash with a recording of the ambient light. After pressing the fire button, move the camera through a sweep of the room until the flash fires. This will give you a kaleidoscope of colours and patterns ending with the subjects being lit by the flash.

See also

Wide-angle
lenses
(page 24)
Depth of field
in portraits
(page 92)

What kinds of expressions are good for fashion photography?

There are clear differences within the types of advertising portraits – these can range from presenting clothes, jewellery or lifestyles. Fashion photography tends to be fickle, and the current twin themes of either po-faced models looking indifferent, or the lifestyle alternative of happy, smiling, carefree expressions could be replaced with something else. It pays to look at fashion magazines to keep abreast of current styles of photography.

A cheeky smile makes for a happy picture (below). Eye contact would have made it even stronger in terms of engaging the viewer.

This is a typical lighting scheme for a moody expression – plenty of dark shadow and a solitary light (right).

If the subject is extremely stiff, how do I get them to relax?

Music is always good for setting moods and encouraging people to relax. It may be worthwhile to turn the radio on before any studio photoshoot. Otherwise, talk to the subject about what kind of images they are looking for and also what kinds of things interest them. If you can get them chatting about their favourite subject while snapping away, they will relax. To do this unobtrusively, do some research before the day of the shoot. A lot depends on how friendly and approachable you are, and whether or not the subject has a fixed image of themselves already. The trick for commercial photographers shooting well-known figures is to bring out that self-image by arranging the lighting and camera positioning.

How do I stop regular portraits from looking cheesy?

This depends a lot on the character of the person. The older they are, the more they tend to be restrained, but this is a huge generalisation. You have to take people individually. The more they relax and the more you can chat and have a joke with them, the better and more natural the smiles and postures will be.

> **Tip**
>
> *If you shoot someone looking lost in thought or nostalgic, use a wide aperture to reduce the depth of field right down and focus on the eyes. The result will be far more intimate and touching, allowing the viewer to empathise with the subject.*

How can I get more emotion from my subject?

If the sitter is looking completely blank-faced, again, ask them about their favourite subjects or interests. Their face will automatically light up and become more animated once they forget about being photographed. For younger sitters, an alternative would be to challenge them to express five different emotions as fast as they can when you start shooting. The very effort of doing this will loosen them up and if you keep shooting, you often get some good shots at the end.

Getting subjects to show emotion can be difficult at times, so the key is to get them to relax. This image has been created specifically to convey sadness.

When are accessories a good idea?

You could also ask the reverse question: when are they not a good idea? If you are just starting out in portrait photography you may have a killer idea complete with lavish set, interesting lighting, colour co-ordination and swathes of jewellery. In which case, go ahead and make that dream shot come to life. Otherwise, keep accessories down to a minimum until you are comfortable with co-ordinating a shoot. Accessories can add to the subject's character and they can also give the subject's hands something to do and focus on.

What are the pitfalls of using stylised props?

At times, this can make the prop have more weight in the picture than the actual subject, and it then becomes the centre of attention. Ensure that easily recognisable props won't date the image. However, this can at times be acceptable as people like to look back at what they wore or used in the past. If you use props or accessories associated with someone famous, the picture may give the impression that the subject is simply dressing up or pretending to be that famous person.

The prop in this picture is not just an artificial device to convey a message – it's the musician's instrument and is a vital part of his self-image. (Image by Brad Kim)

This shot is all about the accessories being used – the ornate mask and the jewellery.

Tip

Young children looking lost and not knowing what to do? Give them their favourite toy or a new one for them to investigate. Snap away as they play.

See also

Group shots (page 104)

SECTION SEVEN

SHOOTING ON LOCATION

A good location is invaluable to portrait photography. It can add a style and resonance to an image that makes it far more engaging and interesting than anything shot in the studio. Where you can shoot and what kinds of locations to look for are dealt with in this section, along with the practical problems that come from being outside. The issues of bright sunlight, candid photography, security and applicable laws are all dealt with. Action portraits are also discussed, wherein people engaged in sporting pursuits can be captured, whether it's for reportage or for the subject themselves, engaged in their favourite pastime.

Shooting on location offers a challenge in terms of lighting, but it rewards the photographer with greater variety of scenes compared to the studio.

What types of city locations are good for taking portraits?

Shooting in the city offers a wealth of opportunity, from modern, glass-fronted office blocks, to cultural districts, the café society, neon nightlife and grand, imperial architecture. If there is a waterfront or harbour, then marine elements can be included as well. The flipside to this is dreary urban decay, abandoned factories and graffiti-festooned tower blocks, which ironically could also produce striking images.

What problems do I need to look out for in the city?

The first and most immediate problem is one of the general public. People will always stop and stare to see what you are doing. If the subject isn't comfortable about being photographed in this kind of environment, then head for somewhere less busy. A second issue is that many areas of cities are privately owned and the owners will jealously guard photographic right of access. For example, the area around Nelson's Column in central London is actually private, and while amateur photography is allowed, anything professional-looking will draw the attention of the security personnel.

Another aspect of security is to be aware of what is in the background. Shooting outside a jewellers' or a bank may draw attention from those inside. The most prevalent security concerns, however, are theft and muggings. In a busy city-centre location, it's all too easy for thieves to just pick up your bags and walk off while you are shooting. The most serious implication is obviously if you are shooting in run-down areas. It pays to ensure that you have extra help on hand, and don't push your luck by shooting in unsafe and unlit areas at night. Camera insurance would be a good idea.

The urban grime of the city is always a good backdrop, especially when you can place something incongruous against it, such as in this image of a man with an orchestral instrument.

See also

Built-in flash and flashguns (page 30)

The countryside provides wide, open spaces and lots of greenery. Make use of this to create a naturalistic portrait with plenty of light.

What does the countryside have to offer?

Rural areas and the countryside are best used in the summer when there are fields full of golden crops and the warm light of a summer's day makes everything seem pleasant. Certainly, it's more fun to shoot in the summer and any trip into the countryside will reveal charming villages, barns, farms, little dirt tracks and plenty of vibrant colour. In the winter time, turn your camera to foggy, atmospheric mornings or snow-covered scenes, either after a snowfall or up in mountainous areas.

Tip

Many country houses that are open to the public, whether privately owned or owned by the State, offer a magnificent backdrop for photography. Don't expect to get permission to photograph inside without paying a large location fee. However, if you approach the owners beforehand and explain your venture, you can often get away with shooting in the gardens or in front of the house for either a minimal fee or for free.

How do I capture moving water with the subject?

The traditional image of flowing water, from a landscape photographer's perspective, is one that uses a long exposure of over four seconds to blur the water. If you want to shoot your subject and get the same kind of effect, you'll have to wait until the light levels are low, such as at dawn or around dusk. You would likely need to employ a neutral-density filter as well to reduce the light level. As the subject is unlikely to stay still for four seconds, it makes sense to use flash in the shot so that rear-curtain mode is used when the flash fires at the end of the exposure. The camera will need to be mounted on a tripod to keep the background sharp.

In this image, the shutter speed used was fast enough to capture the boy running through the water spouts, but slow enough that the water itself has become blurred.

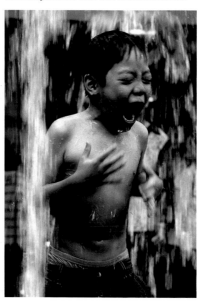

Bright sunlight in the middle of the day is not the photographer's best friend. Any amount of it falling on the subject's face will cause them to squint due to the bright light. (Image by Brad Kim)

It is much better to turn the subject so that their back is to the sun and the face is out of the glare. Use a reflector or fill-flash to brighten up the gloomy foreground. (Image by Brad Kim)

How can I minimise the problem of the subject squinting in bright light?

In sunny weather, it is inevitable that the subject will squint when facing bright light. Even looking up into a bright, white sky can at times be too much. The obvious solution is to have the subject turn away from the sun so that they can open their eyes. However, this leads to a severe contrast in the background light and the light on the subject. The key point here is to prevent the subject from squinting. Move the subject so that they are not looking into bright light and preferably, move them into the shade.

What is flare?

This problem occurs when the subject is backlit by bright sunlight or when shooting towards sunlight through trees, etc. Rings or spots of light appear in the image, which are caused by the strong light going through the numerous elements of the lens.

How can I avoid flare?

Keep the sun well out of the camera frame. Flare can still occur even when simply facing towards the sun, so the only way to completely avoid it is to have the sun to your back.

See also

Diffusion and reflectors (page 35)
Colour temperature (page 54)
Filters (page 56)

Can automatic white balance on digital cameras be fooled while on location?

Yes, quite easily. For example, on a sunny day and with your subject in the shade, the digital camera AWB can try to compensate for the sunlight, resulting in a blue tinge in the shaded areas. The problem also applies to film as the colour temperature of the shade is different from that of the sunlit areas. Equally, just one artificial light in a scene can fool the camera AWB so that all of the scene becomes tinted as a result. The way to get round all this is to manually set the white balance on the camera for the type of conditions that your subject is under, not what is going on in the background.

When is using a high ISO rating a good idea?

Film users have one advantage in that high ISO films tend to give better quality results than the standard DSLR, and certainly the digital compact, at the same ISO rating. Increasing the ISO must always be done with caution when using digital. On compact cameras anything over ISO 400 might be problematic, whereas on a DSLR up to ISO 1250 is generally acceptable. High ISO ratings are useful in locations where there are low light levels and where flash photography would be either frowned upon or ruin the atmosphere, such as festivals and music events.

There are times when using flash is not appropriate - recording stage productions, for example. In this case, a high ISO rating will generate more shutter speed and avoid camera shake.

What is candid photography?

The term 'candid photography' can apply to a wide range of situations. It includes situations where the subjects are unaware of the camera and just going about their daily business. It can also be applied to street photography where the subject is aware of the camera, but the shot is completely unposed and informal. Candid photography can also be used in more personal situations, such as recording family events where the camera is acknowledged and sometimes posed for. However, it is there mainly to capture inter-family relationships.

Candid or street photography is all about capturing the essence of your subject while they are out in the open, going about their daily routines and activities. Candid photography tends to be unobserved, while street photography invites a response from the subject.

What camera is best for candid photography?

In pretty much all cases, the smaller the camera, the better, as it is less obtrusive. If you are intending on capturing street scenes without being spotted, then a digital compact with an articulating screen is ideal as the image can be composed and taken without ever having to look at the subject.

How do I shoot candid photographs on the street?

Assuming you are using a digital compact camera, then an aperture setting of f/5.6 will create enough depth of field, which will allow you to forego general concerns over precise focusing. Digital compacts produce a lot more depth of field than SLRs, thanks to the distance between the very small recording element and the lens.

A sneaky candid photo can capture the subject with a natural expression.

Try to use a camera with an articulating lens or stand somewhere unnoticed where you can easily compose and shoot the images. Otherwise, if you need to shoot while on the move, set the focus to manual and calculate the distance between the camera and the subject. Enter the figure as the manual focusing distance and set off walking. As the focus distance will be roughly correct and there will be plenty of depth of field, all you need to do is press the fire button at the right point, without aiming and pointing the camera at the subject. With the camera already pre-focused there should be little shutter lag as the camera simply needs to meter and fire.

Do I need to pay for portraits?

Not for candids where the subjects are unaware of the camera. However, if you spot someone interesting and ask to take their picture, it would be polite to offer a nominal sum as an acknowledgement. We're only talking a few pounds/dollars/euros, but it can mean that you get a few shots of the same person, rather than just one. It's also worth considering offering them a print.

See also

Digital cameras (page 16)
Telephoto lenses (page 26)

Tip

Be prepared for rejection when asking people on the street for a photograph. Few people like being photographed in situations like this, especially by a stranger. Be polite and walk away.

What are action portraits?

Action portraits could include images of sports, physical activities and hobbies, such as football, cycling, running, gymnastics or swimming. Many people have a favourite or specialist sporting activity; if they are successful in their field, they will often look for portraits of themselves performing their sport.

How do I freeze motion?

As the subject is likely to be moving while performing their chosen activity, the key question is one of freezing motion so that the image is kept sharp. This requires you to be able to focus quickly on the subject and have a fast enough shutter speed to capture the moment. The usual ad hoc guide to minimum shooting speeds was based on the focal length of the lens expressed as a fraction of a second. For example, a 50mm focal length will allow for a sharp picture at 1/50 sec, and a 200mm focal length requires 1/200 sec. However, this should be somewhat extended.
A lot depends on how fast the subject is moving and whether the movement is towards you or parallel to the camera. Instead of shooting at 1/50 sec on your 50mm lens, aim for 1/150 sec.
A 200mm telephoto shot should be backed up with approximately 1/600 sec shooting speed.

Do I need a fast lens?

A fast lens is one with a wide maximum aperture, which in turn lets in more light and gives a faster shooting speed. A 200mm telephoto lens with an f/2.8 maximum aperture would be considered a fast lens, whereas one at f/5.6 would not. However, fast lenses are expensive, and the longer the focal length with a wide aperture, the more expensive they get.

For the enthusiast taking portraits, a 600mm lens with an f/2.8 aperture is simply unaffordable and a complete extravagance. The only real way to tilt the odds in your favour is to use telephoto lenses with a shorter range as they will have a better aperture performance than a super zoom of 28-300mm, for example. You can also use prime lenses, which have even better performance.

Making the subject appear frozen in position while they are moving quickly requires a very fast shutter speed. In this shot, the girl was sprinting to the finish line but a shutter speed of 1/3000 sec on a bright day rendered her motionless.

Tip

When shooting sporting events or people engaged in sports with a view to selling your images for stock photography, try to ensure that any advertising or logos are not in view. Most stock photography libraries would not accept these without written permission from the companies concerned. However, this is usually not the case if the photographs are reportage for newspapers because it is deemed fair use.

Can flash freeze the subjects?

Flash can be very handy in these circumstances because it fires a bright light for a very short period of time, typically between 1/1000 sec to 1/2000 sec. At this speed, most moving subjects will be frozen in position because the flash has supplied all the light the exposure requires in that very brief period of time. Flash, therefore, can be used to freeze the motion of the subject. However, carefully consider whether flash is appropriate and also take note of the subject's distance from the camera. Someone playing football will be out of flash range, whereas firing flash at two people fencing could be downright dangerous.

With someone running across the field of view, rather than towards you, a faster shutter speed is required. If the ambient light isn't sufficient, then flash would be required to provide the instant burst of high-speed light to freeze the movement. (Image by Brad Kim)

Panning shots require a slow shutter speed and moving the camera with the subject. It can be tricky to get the subject pin sharp, but the real aim here is to retain some detail in the subject, while blurring the background. (Image by Brad Kim)

How do I get panning shots?

The other technique used to capture people on the move is the panning shot. This requires the subject to move past the camera on a parallel frame. Here, a fast shutter speed is not required at all. In fact, it is better to set the aperture to something such as f/8 to create a good depth of field and pre-focus on the point at which the subject will move past the camera. Set the focus to manual so it doesn't re-focus and look to have a shutter speed of around 1/8 sec.

As the subject appears just to the right of centre, get them into the viewfinder, press the fire button and move the camera as they move, panning across the scene. They don't need to have moved much before the background becomes a sideways blur and the subject stays relatively sharp.

The other option to employ with the panning technique is to use second curtain or second sync flash with it. The flash then fires at the end of the panning movement, freezing the subject in position, but leaving a trail behind them from the ambient light in the panning movement. You can use a longer shutter speed with this technique

See also

Portrait lenses (page 22)
Lighting outdoors (page 64)
Long exposures (page 72)

Where can't I photograph?

Different countries have different attitudes to public photography, so make yourself familiar with the local customs first and foremost. Generally, you can shoot in open public places without any problem. Bear in mind that somewhere that has members of the public in it does not necessarily make it a public area. Anywhere private will have some kind of regulation and while it may be that amateur photography is accepted, you can't expect to perform a commercial portrait shoot without getting approval and/or paying relevant fees first.

Who can't I photograph?

The general concern over paedophilia and child grooming means that if you point your camera at children other than your own, you are asking for trouble. Even photographing your own kids at a school event could be problematic and may require permission first.

Aside from children, some religious people may not want to be photographed. This also applies to anyone in public places. If people react negatively or unfavourably to being photographed, simply apologise and walk away. Persistence does not bring rewards, it brings the local law enforcement officers.

Do I need a model release form?

This largely depends on who you are supplying the picture to. Any photograph taken in a public place should not need a model release form. However, many stock image agencies will demand a signed model release for anyone who is identifiable in a photograph. For candid photos, this is obviously impractical as well. In general, the answer is no, you don't need one, but some agencies, particularly American ones, will demand one.

Do I need a property release form?

If the portrait in question will be taken in the grounds of somewhere very visually identifiable, then agencies are likely to ask for a location release as well to ensure that you have permission to photograph in your chosen location. More and more country houses and stately buildings are being protective over their image. It will require negotiation/fee payment in order to shoot there in the first place, but having done so, you should also ask for a location release form so you have it on file.

Tip

As a photographer, it always makes sense to have the subjects you are photographing sign a model release form. This could be done with a booking form stating your normal terms and conditions.

See also

Finding good locations (page 114)
Candid photography (page 118)

Model Release

For good and valuable Consideration herein acknowledged as received, and by signing this release I hereby give the Photographer/ Filmmaker and Assigns my permission to license the Images and to use the Images in any Media for any purpose (except pornographic or defamatory) which may include, among others, advertising, promotion, marketing and packaging for any product or service. I agree that the Images may be combined with other images, text and graphics, and cropped, altered or modified. I acknowledge and agree that I have consented to publication of my ethnicity(ies) as indicated below, but understand that other ethnicities may be associated with Images of me by the Photographer/Filmmaker and/or Assigns for descriptive purposes.

I agree that I have no rights to the Images, and all rights to the Images belong to the Photographer/Filmmaker and Assigns. I acknowledge and agree that I have no further right to additional Consideration or accounting, and that I will make no further claim for any reason to Photographer/Filmmaker and/or Assigns. I acknowledge and agree that this release is binding upon my heirs and assigns. I agree that this release is irrevocable, worldwide and perpetual, and will be governed by the laws of the Province of Alberta, Canada.

I represent and warrant that I am at least 18 years of age and have the full legal capacity to execute this release.

Definitions:
"MODEL" means me and includes my appearance, likeness and form.
"MEDIA" means all media including digital, electronic, print, television, film and other media now known or to be invented.
"PHOTOGRAPHER/FILMMAKER" means photographer, illustrator, filmmaker or cinematographer, or any other person or entity photographing or recording me.
"ASSIGNS" means a person or any company to whom Photographer/ Filmmaker has assigned or licensed rights under this release as well as the licensees of any such person or company.
"IMAGES" means all photographs, film or recording taken of me as part of the Shoot.
"CONSIDERATION" means something of value I have received in exchange for the rights granted by me in this release.
"SHOOT" means the photographic or film session described in this form.
"PARENT" means the parent and/or legal guardian of the Model. Parent and Model are referred to together as "we" and "us" in this release.

Photographer/Filmmaker Information
Name (print) _____
Address _____

City _____ State/Province _____
Country _____ Zip/Postal Code _____
Phone _____ Email _____
Shoot Date _____
Shoot Description/Reference _____
Signature _____
Date _____

Model Information
Name (print) _____
Address _____

City _____ State/Province _____
Country _____ Zip/Postal Code _____
Phone _____ Email _____
Date of Birth _____
Signature _____
Date _____

Parent(s) or Guardian(s) (if person is a minor or lacks capacity in the jurisdiction of residence.) Parent warrants and represents that Parent is the legal guardian of Model, and has the full legal capacity to consent to the Shoot and to execute this release OF ALL RIGHTS IN MODEL'S IMAGES.

Name (print) _____
Address _____

City _____ State/Province _____
Country _____ Zip/Postal Code _____
Phone _____ Email _____
Signature _____
Date _____

Additional information to be completed by Model: (Optional)
Ethnicity information is requested for descriptive purposes only, and serves as a means of providing more accuracy in assigning search words.

___Asian ___Caucasian, White ___Hispanic, Latin
___Middle Eastern ___Native American ___Pacific Islander
___Black ___Mixed Race ___African American
Other: _____

Attach Visual reference of Model here: (Optional)
For example, Polaroid, drivers license, print, photocopy, etc.

Witness (NOTE: All persons signing and witnessing must be of legal age and capacity in the area in which this Release is signed. A person cannot witness their own release)
Name (print) _____
Signature _____
Date _____

This is an example of a model release form used by stock libraries. It has more detail than is strictly necessary for many applications in order to cover all and any eventualities, as images could be purchased and used for anything.

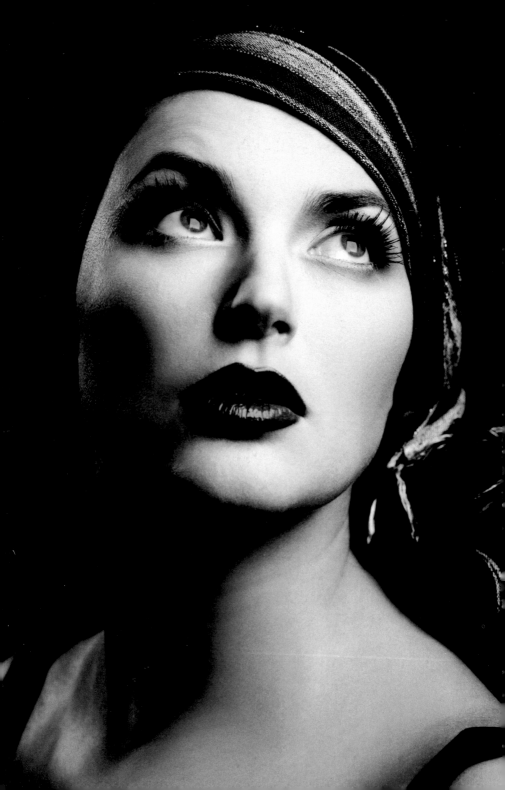

SECTION EIGHT

THE DIGITAL DARKROOM

Retouching photographs dates back almost a hundred years, when large plates made it easy for an army of pencil and ink artists to improve portraits. In the digital age, it doesn't matter whether your original image comes from a digital camera or is scanned in from film. Once the image is on the computer, software can correct mistakes and improve exposures. There's a saying that 'Photoshop won't make a bad photo good', but it will prevent a good photograph from becoming a bad one. On top of bringing details out of shadows, restoring highlights and improving colour and contrast, the digital photo editor can also improve the physical appearance of the subjects, turn colour images to black and white, and add subtle tints.

It doesn't matter whether your original image was captured on film or digital, the computer is where it can take on new life.

How do I fix under or overexposure?

Load your image into Photoshop or your favourite photo-editing package and have a look at the histogram. If it shows a gap on the left, it means the picture is overexposed; if there is a gap on the right, it is underexposed. The bigger the gap, the worse the problem. The first thing that can be done is to use the Levels command to spread out the tones in the picture so that they use the entire tonal range in the file.

The original image is a little underexposed and dark. The limitations of digital imaging have been revealed by the reflected light on the shoulder area, losing the highlights.

How do I bring out shadow detail?

Photoshop CS3 has the marvellous Shadow/Highlight tool, which can be used to bring out hidden detail in the shadow areas. Other packages may not have this tool, so Curves becomes the next best tool option. This allows a smooth brightening or darkening of an image, along with control over shadows, mid-tones and highlights.

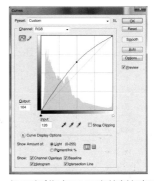

As most of the image needed brightening, a Curves adjustment layer is used to lighten the shadow and mid-tone areas of the photo.

How can I repair blown highlights?

In the example image, the top of the arm has lost detail, as well as the white sleeveless top. The arm itself is easy to repair. Simply select the Clone Stamp tool, set it to around 18 per cent opacity with the large feathered brush, and sweep up from the areas that have texture into the areas that don't. By using such a low opacity and repeated strokes, the effect is smooth and convincing.

Note the red circle showing the histogram. The majority of this picture is dark, but the highlights on the shoulder have burnt out.

The layer mask that comes with the adjustment layer can then be painted on to stop the bright areas on the subject getting any brighter.

This is best performed on a duplicate layer so any mistakes can be rectified. Also, avoid the edges of the arm as sources for the Clone brush as this will paint straight lines into the areas that are meant to be soft.

This is the actual finished image where detail was restored in the arm, but the white top area lacked any real sample areas. As a result, the image was brightened and toned to make it look more like a warm summer day. The image was softened in places in order to add to the general ambience, and also to help hide the blown highlights that couldn't be easily repaired.

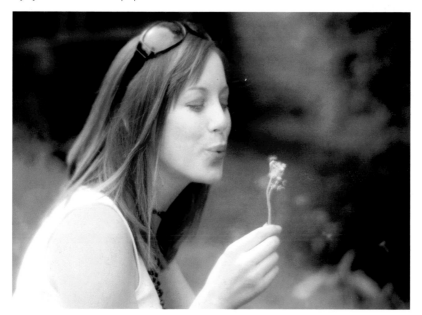

My subject has something sticking out of their head. What has gone wrong and how do I fix it?

This problem occurs when using too narrow an aperture for the distance between the subject and the background. As such, the background appears in sharp focus, and background objects with the subject, usually the head. The worst examples are poles or flower pots that appear to be growing from the head, although brightly burning household lamps can be equally distracting.

How you fix this depends on the level of the problem. If it's an isolated element, such as a pole or plant, then the Clone Stamp tool can be used to erase the object in the background. If the entire background is intrusive and distracting, the solution is a lot trickier. The background must be masked off and given a slight blur to make it more diffused. If the subject's feet are clearly seen in the shot, it's even harder, as you will need to both blur the background and use a layer mask with a graduated fill to make the out-of-focus effect grow more pronounced as it goes into the background.

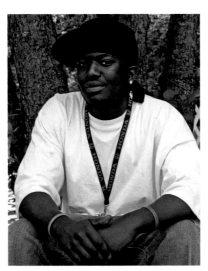

This image is fine, but the background in this picture is quite sharp.

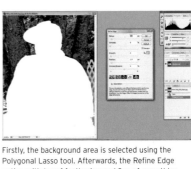

Firstly, the background area is selected using the Polygonal Lasso tool. Afterwards, the Refine Edge option with 1px of feathering and 3px of smoothing is used to refine the selection.

The Gaussian Blur filter is then used with a radius of 5px to smooth out and knock back the background. Beware of over-using this as it will create a halo around the subject.

See also

Portrait lenses (page 22)
Depth of field in portraits (page 92)

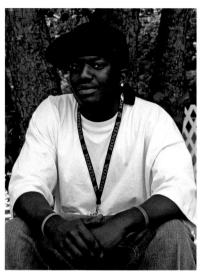

This is the final version with a softened background.

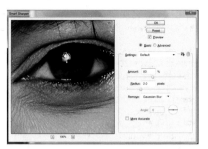

The new Smart Sharpen function in Photoshop CS3 differs from Unsharp Mask in that it genuinely sharpens the image, showing more detail, but making the image noisier and grainier.

The picture is too soft. How can it be sharpened?

The traditional photo-editing tool here is the Unsharp Mask, named after a chemical darkroom technique. This doesn't actually sharpen an image – it finds the edges between light and dark areas and makes them more pronounced. This gives the illusion of making the picture sharper and it has the side effect of putting more contrast into the picture. High-contrast pictures automatically look sharper than ones with a limited tonal range. However, the downside to the USM filter is that it can create halo effects around objects, particularly those that intrude into the sky or the horizon. Photoshop CS3 has a new tool called Smart Sharpen that is much more effective at actually sharpening an image. However, it does result in a grainier and coarser look.

The picture is out of focus. Can it be saved?

Many things can be fixed with photo-editing, but unfortunately the out-of-focus picture isn't one of them. If it's slightly out of focus, then sharpening will bring it back. If it isn't to be printed at a large size, then the result can be acceptable. If it's completely out of focus then it cannot be redeemed.

The picture has camera shake. What can be done?

This is different from being out of focus in that there are usually double lines to objects as a result of movement during the exposure. If you are desperate to save the image, you can clone out the secondary image lines around the subject and any other objects, particularly those with straight lines. Afterwards, apply the Smart Sharpen tool to sharpen the rest of it. Of course, it will never be as sharp or clean as an original image that was shot and recorded properly.

How can I fix a colour cast on the computer?

The exact method of fixing colours is dependent upon the software being used. You could use one of the RAW file-editing packages available for digital cameras. These usually allow RAW or TIFF files to be loaded and the colour temperature reset to one where the colour cast is negated.

There are also other methods available in your regular photo-editing package starting with adjusting the Hue/Saturation. This is usually the least precise method, but it allows a specific shade to be selected and the hue to be adjusted along a slider. A better option in Photoshop is the Variations tool. This should be applied to a duplicate layer so that control can be exercised over how much of it is used. With this, it is easy to pick out the colour cast – simply click on the opposite colour in the display to counteract it. There is no control over the amount and this is why it's best to use the duplicate layer and use the Opacity to set how much is applied.

Better than either of these methods is the Color Balance option. This presents sliders for Cyan-Red, Magenta-Green and Yellow-Blue so that the exact amount of counteracting colour can be applied across different colour channels at the same time.

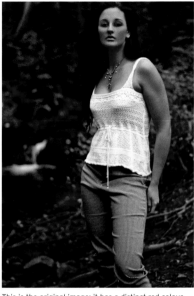

This is the original image; it has a distinct red colour cast because the wrong white balance setting was used on the digital camera.

The Hue/Saturation slider can make some impact, but the way it controls colour shifts is too imprecise.

See also

Colour temperature (page 54)
Filters (page 56)

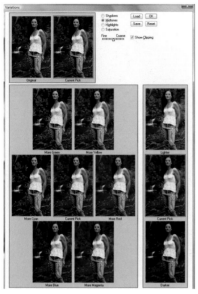

Variations is a quick and easy method of counteracting a colour cast, but it needs to be applied to a duplicate layer as it lacks control.

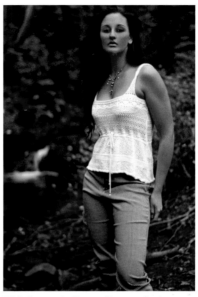

This is the corrected image with more natural-looking colours.

A better option is to use Color Balance and adjust the sliders. It offers much more precision on all three colour channels at once and the cast can be removed.

How do I isolate just one colour?

While this sounds a reasonable question, a colour is usually made up of various shades of the same colour. You can isolate colour by using the Replace Color function in Photoshop, where the picker selects the colour on screen. The Fuzziness control then sets how much variation in the shade of that colour is picked up. This isn't recommended as an option for selecting the skin tones, but if you want to replace a background colour, such as in a room or a car, then it can be useful. Click on the square Result block of colour to select the replacement colour then adjust the Hue and Saturation as required.

Use the Clone Stamp tool in Lighten mode to click and remove spots and facial blemishes.

Use the Burn (or Darken, if available) brush at around 5 per cent to finish it off.

How can I smooth out complexion?

We've all seen the Sunday supplements and fashion magazines featuring models with super-shiny faces and glowing complexions. Good diet and exercise, right? Wrong. It's all done in Photoshop, as seen in the following images.

How can I remove spots and pimples?

Complexion blemishes are part of portrait photographs, but everyone wants to look their best, so photo editing can lend a helping hand. Adobe Photoshop itself has a Healing brush that can be used to repair spots and lines on the face. However, it is less useful for larger areas such as dark rings under the eyes. Other packages have similar tools, but these vary.

One thing that almost all photo-editing packages have is the Clone Stamp tool (see above image) – and this can be used for cleaning up faces. To remove isolated spots, set the blend mode to Lighten (because the spot is usually darker than the surrounding area), set the Opacity to 100 per cent (to preserve sharpness) and sample from just to one side of the spot itself. Click on the spot to remove it. If there is a trace left, change the blend mode to Normal, sample from a different area and click on the bit that has been missed.

The first thing to do is to remove all the spots using the technique described. Next, create a duplicate layer to work on.

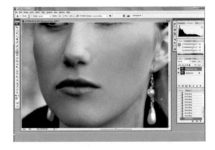

Select the Clone Stamp tool and set the blend mode to Normal and the Opacity between 18 to 20 per cent. Select a fair-sized brush. If it's too small, then there won't be enough feathered edge or smoothing. If the brush is too large, then it's difficult to avoid going over the edges of the face and features. Sample from similar shades of brightness areas and smooth over features. Work in the directions the features run in. A good place to start is the cheekbones.

How do I fix red-eye?

Use a dedicated red-eye removal brush or select the Clone Stamp tool. Set the blend mode to Color and set the foreground colour itself to black. Opacity should be 100 per cent. Now paint in the centre of the eye to remove the red area.

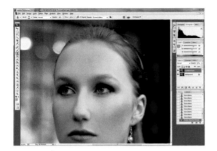

Resample often in order to avoid repeating patterns. Don't overwork an area or you will lose all texture and the face will look unnatural. From the cheekbones, work up to below the eye, removing shadows. Go downwards towards the lip and tidy up slightly puffy cheeks. Be careful when working from the chin and along the jawline – they are normally different shades. Work them towards each other and not all the way across. Do a little work on the nose and smooth down between the eyebrows, removing lines whilst also tidying up hairs. Finally, smooth out the forehead, but be careful not to make it all one shade. Work the sides into where the forehead flattens out. Now assess the final result. Does it look glossy or have you overdone it? If required, start reducing the modified layer opacity, letting original texture back in until it looks realistic, but smooth.

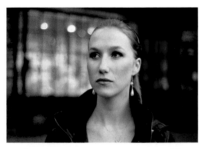

This is the original image, having been brightened with Levels and Curves, prior to any work on the face.

Here's the final image with the subject benefiting from a clear complexion and supermodel-smooth skin.

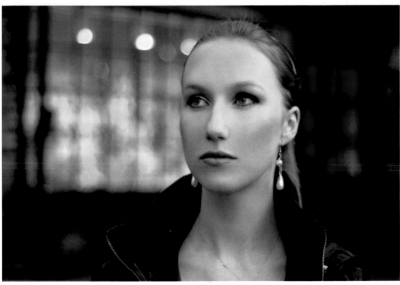

What are the different ways of converting to black and white?

The beauty of Photoshop is that it doesn't matter whether your original image is a digital one or whether you've scanned colour film – it offers the same conversion facilities to both. Other software packages have plenty of similar features.

Of the various tools and options the worst ones are the Desaturation and Greyscale mode as they offer no control over the conversion process. Converting to LAB mode and removing the colour channels are not much better either. I would not recommend using any of these methods. Bear in mind that no matter what the conversion process, in an 8-bit digital file, you only get 256 monochrome shades, which includes black and white. What matters is how you convert the image to use all those shades. In Photoshop CS3 and a number of other photo-editing packages, this leaves the Channel Mixer or a mono-gradient map.

For quick fixes, a black-white gradient will give a punchy contrast conversion with no effort at all. It usually relies on the original image having a wide spread of tones. Otherwise, the Channel Mixer, with a tick in the Monochrome box, allows different amounts of red, green and blue channels to be used for the black-and-white conversion.

The three channels offer access to different tools as the red one primarily deals with skin tones, while the blue one covers the sky, and the green one the landscape. The higher the percentage of any channel used, the lighter or more towards white the mono effect of the colour channel will be. A high red channel percentage will result in white, ghostly skin tones in Caucasian subjects. In CS3, this is superseded by the Black-and-white filter. This contains the three primary colours from the RGB model, but also the secondary ones – cyan, magenta and yellow – which allows for a good deal of fine-tuning. The filter also comes with some presets, such as infrared emulation and the effects of coloured filters.

A Channel Mixer adjustment layer is being used to control the three primary colours that are converted to monochrome.

The Black-and-white filter in Photoshop CS3 offers primary and secondary colour channels for a more precise monochrome conversion.

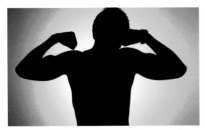

This is the original colour image, which uses a spot on a coloured background with no foreground light, creating a silhouette.

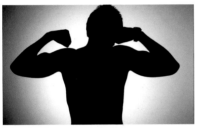

The image is converted to black and white, using each colour channel separately in a Channel Mixer adjustment layer.

What subjects work well in black and white?

All kinds of portraits can look good in monochrome, from simplistic shots of babies or stylised studio shots, to carefree, lifestyle images. If you find an old man with a beard sitting on some fishing baskets, get your camera ready with black and white in mind.

How do I add grain and texture?

The one drawback, if it is that, of shooting digitally in colour is that the pictures are very clean and sharp. To add grain and texture to an image go to Filter > Texture > Grain in Photoshop. You can choose all manner of effects from simple noise-like results to stripey patterns and heavy-contrast grain.

The grain filter in Photoshop allows you to put some texture and variation into what can otherwise be very clean, but sterile digital images.

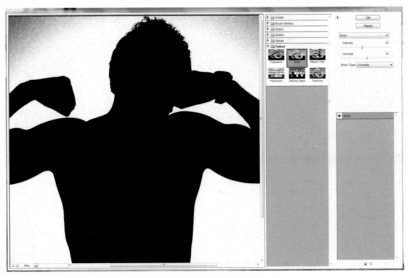

What are the various options for colouring a photograph?

This obviously depends on the software package being used. For example, Photoshop allows all manner of control from simple colouring for printing on your inkjet, to duotone printing on a specialist printing press. You can play with the colour balance of the image, increasing one shade at the expense of another, delve into the duotone world – even if only to convert the image back to RGB afterwards – or stick with the simple toning of Variations.

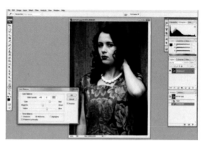

Just altering the colour balance of this desaturated image will give it a colour tint.

Why do duotone images have to be changed to greyscale first?

This is because duotoning is based around a greyscale printing process. A greyscale image has 255 shades, but a printing press may only have around 50 shades per ink. The result would be very coarse and grainy. By adding another ink, you get a duotone, which increases the tonal range and subtlety of the image. Typically, a duotone image would have a black ink and a grey one for mid-tones and highlights. However, there are all manner of colours that can be added based around specific printing methods, which give coloured tinting results. Adding another ink makes the image a tri-tone; another makes it a quad-tone.

The original image was a good candidate for toning because of the period styling and the general lack of colour.

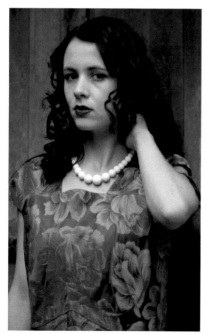

Here, a Pantone colour is used for a duotone to tint the image. For use at home, it is better to convert the image back to RGB afterwards.

What do I do with my duotoned image for printing at home?

Turn it back into an RGB or CMYK image. This converts the ink information into the equivalent RGB shade.

What's the simplest method to use to give my image a single colour tone?

You'll need to use Photoshop's Variations tool for this. Other packages have similar general tinting options. Firstly, convert the image to black and white through your preferred method. Then, go to Image > Adjustments > Variations. This allows you to add green, yellow, red, cyan, blue and magenta in different combinations to see how the mix works. It's not that subtle, so it's best to use this on a duplicate layer and reduce the opacity until it looks right.

Is it worth tinting an image one colour?

Yes, because it takes the simplicity of monochrome while allowing a subtle flavour of colour in. It can be used to do different things. A sepia-like tone will make the image look older, which will go well with a period-themed photo. Half the fun is producing different tinted versions of the same image and presenting them together.

See also

Colour concerns (page 58)
Black and white (page 60)

The finished image has a sepia-like tone that emphasises the period nature of the outfit and location.

The Variations tool allows colours to be mixed to create combination shades.

SUBJECT INDEX

ACKNOWLEDGEMENTS

I would like to thank Caroline Walmsley and Brian Morris for the commission and Renee Last at AVA Publishing for her hard work on this book. Thanks also to Sarah Jameson for nifty picture research at short notice. I'd like to thank Bowens (www.bowens.co.uk) for their picture assistance and model Sophie Smith (contact@sophiesmithmodelling.co.uk) for her sterling work. Thank you also to Indexing Specialists (UK) Ltd. To all the people who made a contribution – my thanks to you all for making the effort.

CREDITS